IMAGES
of America

BOSTON'S BACK BAY
IN THE VICTORIAN ERA

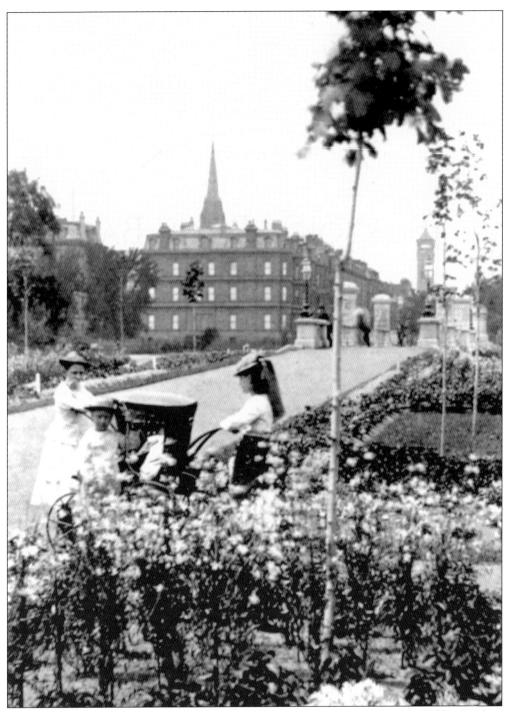

A nurse and her young charges are shown c. 1880 on a pathway in the Boston Public Garden, near Gilman's iron suspension bridge spanning the lagoon. The two church spires in the distance are the Church of the Unity (now Covenant), on the left, and the Brattle Square Church (now First Baptist). The townhouse in the center distance was the James Little house at 2 Commonwealth Avenue, now the site of the Carleton House. (Author's collection.)

IMAGES
of America

BOSTON'S BACK BAY
IN THE VICTORIAN ERA

Anthony Mitchell Sammarco

ARCADIA
PUBLISHING

Published by Arcadia Publishing
Charleston SC, Chicago IL, Portsmouth NH, San Francisco CA

Printed in the United States of America

Library of Congress Catalog Card Number: 2003108412

For all general information contact Arcadia Publishing at:
Telephone 843-853-2070
Fax 843-853-0044
E-mail sales@arcadiapublishing.com
For customer service and orders:
Toll-Free 1-888-313-2665

Visit us on the Internet at www.arcadiapublishing.com

For Edward W. Gordon, a friend, confidant, and partner in crime.

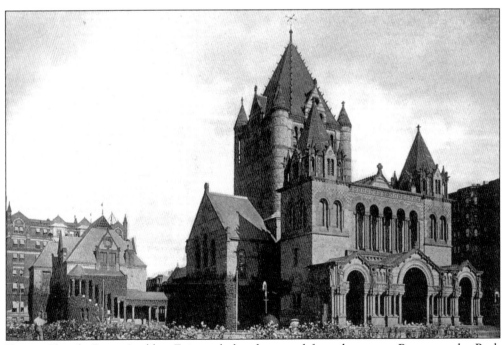

Trinity Church, Boston's oldest Episcopal church, moved from downtown Boston to the Back Bay following the Great Boston Fire of 1872, which destroyed the church at Summer and Hawley Streets. Designed by Gambrill and Richardson in the French Romanesque style and considered today to be their masterpiece, it dominates Copley Square and was consecrated in 1877.

CONTENTS

ACKNOWLEDGMENTS

I would like to thank the following who assisted me, either directly or indirectly, in the writing of this book: the Bay State Historical League; Anthony Bognanno; Henry Carr; Samuel and Rosamond Whitney Carr; Frank Cheney; Lorna Condon; the Society for the Preservation of New England Antiquities Library and Archives; Dexter; Jennifer Durgin, my editor; the Captain Forbes House Museum; Christine Sullivan, the director of the Captain Forbes House Museum; John B. Fox Jr.; the Gibson House Museum; the late Rosamond Gifford; Edward W. Gordon; Helen Hannon; Brett Jackson; Sally Kydd; Nadine Leary; Paul Leo, whose evening at the Savoy in London made it all seem worthwhile; the Milton Public Library; Rev. Michael Parise; William H. Pear II; Fran Perkins; Sally Pierce, the Boston Athenaeum print room; J.B. Price; E. Bradley Richardson; Charlie Rosenberg; Anthony and Mary Mitchell Sammarco; Aaron Schmidt at the print department of the Boston Public Library; Robert Bayard Severy; the Urban College of Boston; William Varrell; the Victorian Society in America, New England chapter; and Josh Wiesner.

A portion of the royalties from this book will benefit the Society for the Preservation of New England Antiquities Library and Archives .

INTRODUCTION

Wherever land can be made economically, on the circumference of the city,
without destroying commercial advantage, there it is bound to appear.
—*Boston Almanac*, 1855

Settled in 1630 by a group of Puritans seeking religious freedom, Boston was an 800-acre peninsula projecting from the mainland at Roxbury. The Neck, or present-day Washington Street in the South End, connected the crab-shaped town, and it remained as such for nearly two centuries until the early 19th century, when topographical changes began to take place with the leveling of Beacon Hill with the fill being used to create the flat of the hill between Charles Street and the river. The infilling of Dock Square for the new Faneuil Hall Market, now called Quincy Market, from 1822 to 1826 created new buildable land. The new South End, a large development in the 1840s and 1850s, was a planned residential district of brick row houses with numerous squares such as Union and Chester Parks and Rutland and Concord Squares.

In 1814, the Boston and Roxbury Mill Corporation was chartered, which was to use the waterpower of the basin by dams built across it. The dams were to have roads above them linking Boston to Roxbury and Brookline. The Mill Dam was laid as an extension of Beacon Street to Brookline, and the Cross Dam led to Roxbury. These roads became Beacon Street and Parker (now Hemenway) Streets, respectively. Completed in 1821, the Mill Dam served its purposes admirably and acted as a toll road to Brookline. In 1831, with the opening of the Boston and Providence Railroad, a further crossway was laid through the Back Bay, with the railway heading south from the Park Square terminus. All of this development and the damming of the Back Bay from the tidal flow of the Charles River caused the area to stagnate. With a large part of the city's sewerage draining into the basin, it became not only a sanitary but a noxious offense, as it was under water at high tide, and at low tide it was a mud flat, reeking with waste and sewage. This hastened city officials to seriously contemplate the immediate infilling of the basin. The area just west of the Boston Common had been infilled between Beacon and Boylston Streets and was to be laid out as the Boston Public Garden in 1837, but the Back Bay and its noxious odors had become offensive and demanded attention.

By 1849, the "Back Bay nuisance," as it had become known, was first addressed seriously when a land commission was appointed by the Commonwealth of Massachusetts to deal with the subject of creating new land from the marshland of the Back Bay. A comprehensive plan was drawn up by the firm of Garbett and Wood and presented in 1852. The land was to be

7

divided with the mill corporation taking control of the territory north of the Mill Dam, and the Commonwealth taking the territory east and west of a line near the Boston and Providence Railroad. The Water Power Company took all territory south of that line. The plan, one of many presented, to design the Back Bay was undertaken by Arthur Gilman, a prominent architect in partnership with Gridley J. Fox Bryant. Earlier in the century, Abel Bowen, a nephew of the entrepreneur Daniel Bowen, showman and curator of the Columbian Museum, had sketched a plan of the Back Bay with row houses sharing a uniform setback from the street with shared rooflines and a center treelined park. Gilman's plan called for cross streets beginning at the Boston Public Garden and continuing west to the Muddy River, between Boylston Street and the Mill Dam, or Beacon Street. However, the infilling of the marshland of the Back Bay was a monumental task that was to take close to three decades to complete and was done under the auspices of the Back Bay Park Improvement.

In 1857, the infilling of the Back Bay marshland began through the ingenuity of John Souther, a resident of South Boston and an engineer. Souther owned the Globe Locomotive Works and had been successful in designing machinery used in the sugar plantations in Cuba; he was thought to be eminently suited to this task. In the 1850s, he was approached by the Commonwealth to oversee the filling of the marshland, which was undertaken by the contracting firm of Goss and Munson. The fill was brought by train from Needham, a town 12 miles west of Boston, to the Back Bay in 35 gondola cars that ran 24 hours a day, 6 days a week, and every 45 minutes. The fill was dredged from the hills in Needham (the area of Gould Street near Route 128) by steam shovels designed by Souther that filled the railcars. Upon arrival in the Back Bay, the cars were tipped on a spring action, spilling the contents into the area to be filled. The fill had an average depth of 20 feet, and the expanse of the Back Bay to be filled was roughly 460 acres. The lots were filled lower than the streets laid out by Gilman, as each townhouse had a basement that would be below street level. Though a monumental task, it is said that only 80 men worked on the project, which included the loading of the cars, transportation, and dumping. So successful was this venture that by 1885, only a small area was left unfilled, near the area of the Back Bay Fens along the Muddy River.

The filled land, known initially as the New West End, but later be known as Boston's Back Bay, was laid out according to Arthur Gilman's plan. The east-west streets, such as Marlborough and Newbury Streets, were named for parts of 18th-century Washington Street in downtown Boston; Boylston Street was named for Dr. Boylston, who donated Boylston Hall at the corner of Washington Street; Beacon Street was named after the old wood beacon that once surmounted the hill by that name. However, the great Commonwealth Avenue was named for the state. It was a 240-foot-wide expanse from one house to the other, and it had a broad treelined avenue that became known as the Mall. The cross streets were named after British earldoms and were not just alphabetically named (Arlington, Berkeley, Clarendon, Dartmouth, Exeter, Fairfield, Gloucester, and Hereford Streets), but the names also alternated between trisyllabic and disyllabic words.

The Commonwealth of Massachusetts had received money from the sale of the newly created Back Bay land. Every lot sold ensured that the state's share of the sales went to a fund administered by the state treasurer that was used to directly benefit the citizens of Massachusetts with funds being allocated to the Massachusetts School Fund, Harvard College's Museum of Cooperative Zoology, Tufts College, Massachusetts Institute of Technology, Amherst College, and Williams College.

The concept for the Back Bay was to re-create the atmosphere of the grand urbane living of the sophisticated Second French Empire of Louis Napoleon in Paris. As one book said in the late 19th century, "the Back Bay of today (1883) is characterized by broad, handsome streets, and the significance or peculiarity of its architecture, both in its public buildings and private dwellings."

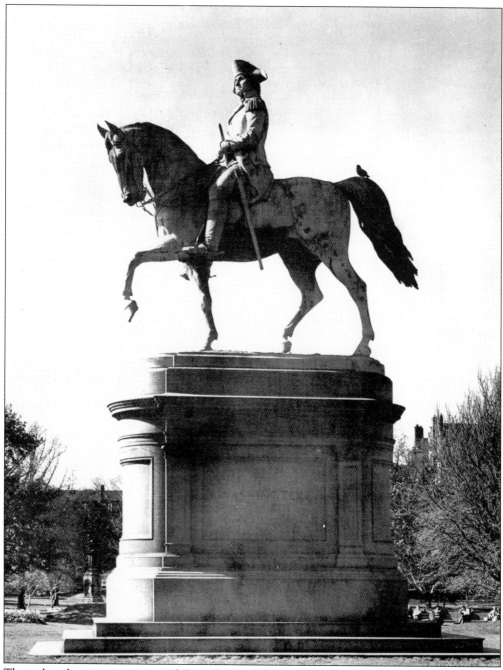

The colossal equestrian statue of Gen. George Washington was sculpted by Thomas Ball and erected in the Public Garden facing south toward the Commonwealth Avenue Mall. Cast by the Ames Company in Chicopee, it was placed on a foundation designed by T.H. Bartlett, and it was unveiled to popular acclaim on July 3, 1869. (Author's collection.)

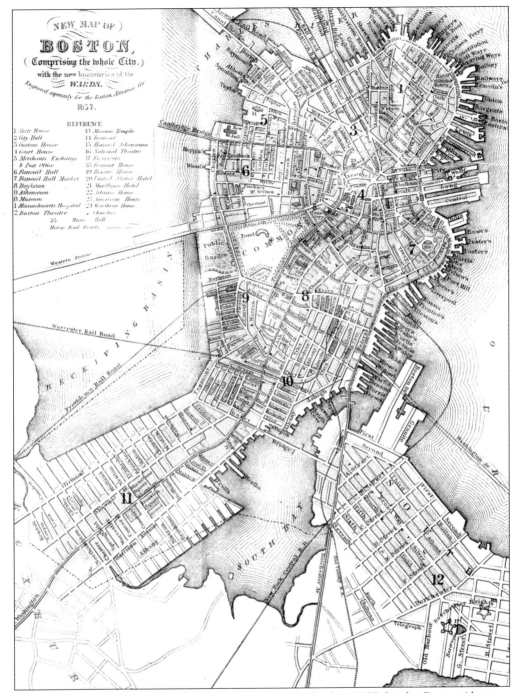

New Map of Boston Comprising the Whole City was published in 1857 for the *Boston Almanac*. It shows the original Boston settled in 1630 enlarged with the South End in the lower center with the proposed infilling of the Back Bay above. On the lower right is South Boston, annexed in 1804 from Dorchester. Extending west from the Boston Public Garden, the new land was bounded by the Mill Dam (called Western Avenue, now Beacon Street) and the Muddy River (now the Fenway). (Author's collection.)

One

THE BOSTON
PUBLIC GARDEN

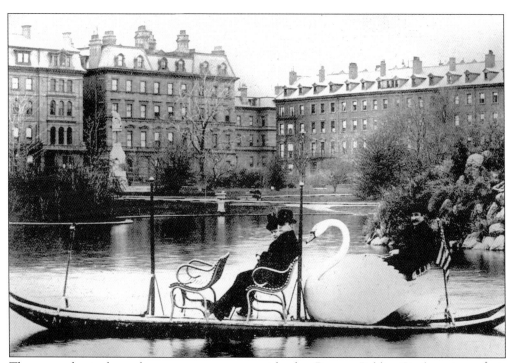

The swan boats have become synonymous with the Boston Public Garden since their introduction in 1877 by the Paget family A fashionable couple rides a swan boat c. 1895 as the mustachioed man on the right pedals the craft around the lagoon. On the left are the townhouses along Arlington Street, and on the right is a row designed by George M. Dexter that was built between 1849 and 1852 on Beacon Street.

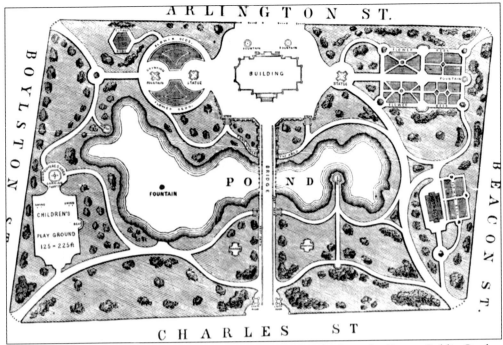

George F. Meacham, a noted architect practicing in Boston, laid out the Boston Public Garden with an irregularly shaped center pond, referred to as the lagoon, with a greenhouse in the center near Arlington Street, formal flower beds on either side, and a children's playground near Charles Street. This plan also had serpentine pathways that allowed visitors to admire the trees, flowers, and statuary embellishing the garden.

Asa Gray was a professor of botany and vegetable physiology and was a noted horticulturalist and founder of the Gray Herbarium at Harvard College. He was active in the development of the Boston Public Garden as not just a pleasure garden but a place where botanical experiments and hybridization of plants could take place by his fellow members of the Massachusetts Horticultural Society.

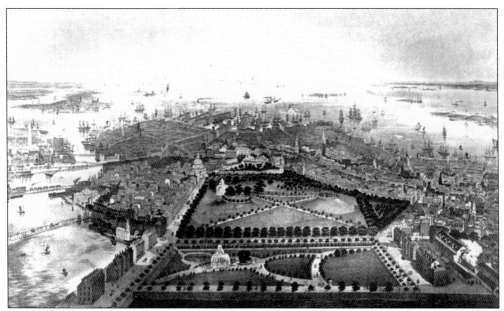

A Bird's Eye View of Boston and Its Surroundings in 1850, a lithograph by J. Bachman, shows a bustling and densely built-up city, with the Boston Public Garden in the foreground flanked by the Mill Dam (Beacon Street) on the left and Boylston Street on the right. The Boston Common, in the center, had been open pasture land owned in common by the residents of Boston since its founding in 1630 by the Puritans.

Marshall Pinckney Wilder (1798–1886) was president of the Massachusetts Horticultural Society from 1840 to 1848 and an avid hybridizer of fruits on his estate, Hawthorne Grove, in Dorchester. He was to donate large numbers of plants from his estate that were used in the planting of the Public Garden in the 1840s, including the *Camellias wilderi*, which he had hybridized and named for himself and was the showpiece of the Camellia House.

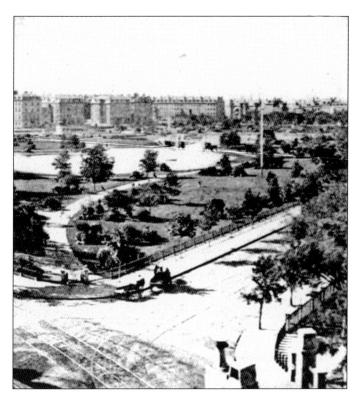

This 1860 view, from the corner of Charles and Boylston Streets, shows the Boston Public Garden, which had been laid out with an irregularly shaped center lagoon and serpentine pathways that were planted with rare specimen trees. The Public Garden was surrounded on three sides by row houses, and on the fourth, seen on the right, is the Boston Common, which had been open land since 1630. (Author's collection.)

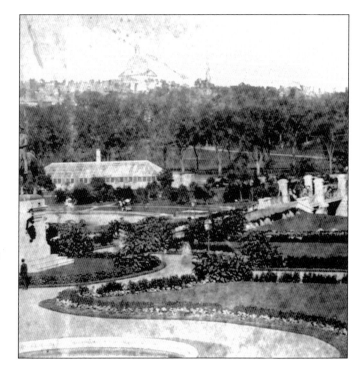

The glass conservatory, or the Camellia House, seen on the left in this stereoview from 1860, was a large glass greenhouse where many of Marshall Wilder's hybrid camellias, some the size of trees, were displayed. As early as 1837, when the land was infilled, botanical gardens and a greenhouse were located here and used by members of the Massachusetts Horticultural Society. (Author's collection.)

The glass conservatory was a place where Bostonians would often stroll to admire the plants that thrived during the cold winter months in Boston and the birds that were kept here. The Boston Public Garden, since it was opened, had attracted people who enjoyed the 24-acre park and beautifully planted flower beds. (Author's collection.)

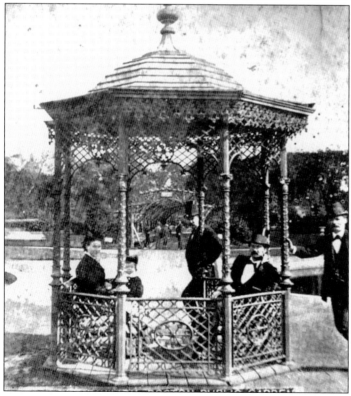

A group of friends poses for a photograph in 1860 at the cast-iron pavilion at the Boston Public Garden. Cast in South Boston, this octagonal pavilion was easily assembled on site, and with its wood-shingle roof, it was not just a place to sit and enjoy the scenery but a decorative feature to the grounds. (Author's collection.)

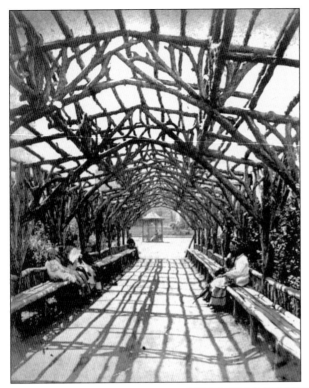

The pergola at the Boston Public Garden was constructed of rough branches and limbs of trees that were interlaced to create a rustic arbor that was eventually planted with wisteria. Here, strollers in the garden rest on benches that line the long sides of the pergola. In the distance can be seen the cast-iron pavilion. (Author's collection.)

Two fashionably dressed girls pose c. 1865 at the entrance to the pergola. The Back Bay was a neighborhood that had been developed with houses having a short front space adjacent to the sidewalk and a service yard in the rear for tradesmen and deliveries. The Boston Public Garden was the playground for the children of the Back Bay and Beacon Hill. (Author's collection.)

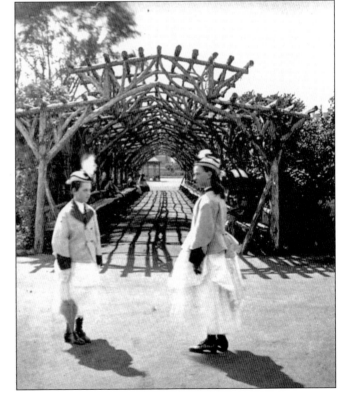

The lagoon, a delightful man-made body of water in the center of the Boston Public Garden, was an irregularly shaped design that looked larger than it actually was. An iron suspension bridge, designed by William Gibbons Preston and civil engineer Clemens Herschel, was built in 1867 to connect the two sides. (Author's collection.)

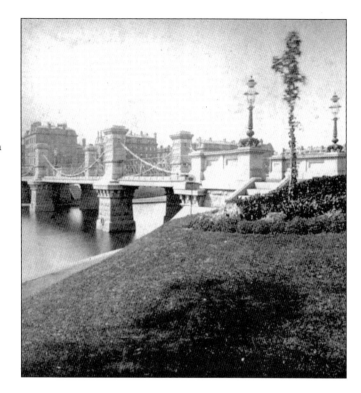

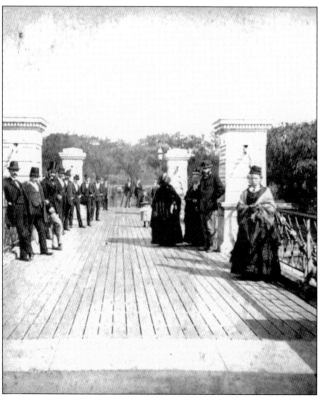

A large group of Bostonians poses c. 1868 on the suspension bridge designed by William Gibbons Preston as a true suspension bridge. It was the smallest in the world. The massive granite piers dwarf the woman in the foreground, and the Commonwealth Avenue Mall can be seen in the distance. (Author's collection.)

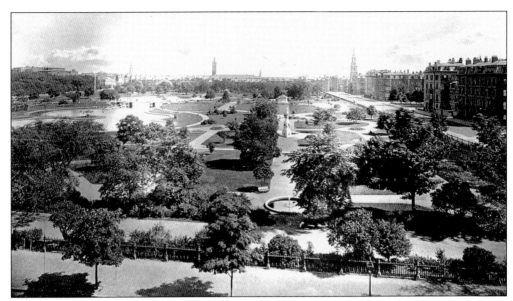

The Boston Public Garden, seen from Beacon Street in the early 1880s, had been laid out in 1860 as a botanical garden with serpentine pathways, formal gardens, and a center lagoon, seen on the left, that was entirely man made from the marshlands of the Back Bay. Embellished with statuary and monuments and enclosed by a cast-iron fence, the Public Garden was a delightful respite from city life. On the right is Arlington Street. The spire of the Arlington Street Church can be seen in the distance.

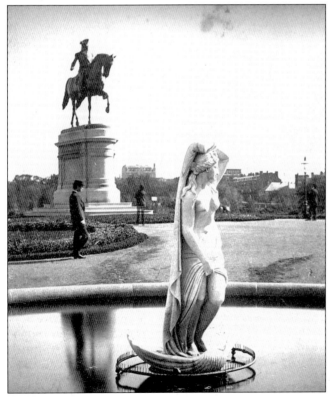

The Maid of the Mist—or "Venus on the Half Shell," as she was often referred to—was a gift to the city of Boston by Joshua Bates and placed in the Public Garden in 1860. The statue was set in a large fountain near the equestrian statue of Gen. George Washington. Bates was an American representative to Baring Brothers in London and a benefactor to the Boston Public Library. (Author's collection.)

The equestrian statue of Gen. George Washington was designed by Thomas Ball (1819–1911) and cast by the Ames Company in Chicopee. Placed on a 16-foot-high granite base designed by T.H. Bartlett, the statue was said to be "graceful in outline and strong in character." Facing west and the Commonwealth Avenue Mall, it is a fine example of public art. (Author's collection.)

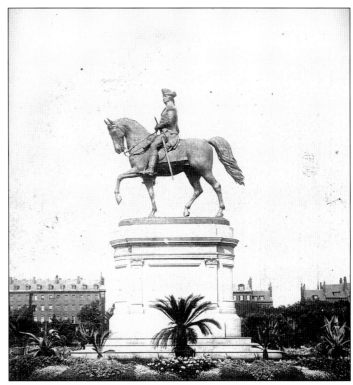

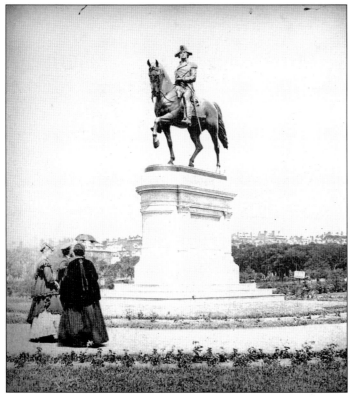

Women converse near the Washington statue in 1869 shortly after it was dedicated. Notice the flower beds in the foreground that have been planted in the late spring and that created a vivid mass of color throughout the Public Garden. (Author's collection.)

19

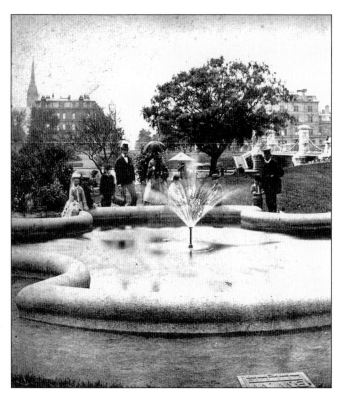

Visitors to the Public Garden stand near a fountain near the lagoon. The attraction of the Public Garden was its accessibility to the Back Bay and Beacon Hill and its many amenities, including beautiful flower beds, specimen trees, and playing fountains. In the distance are the townhouses on Arlington Street and Commonwealth Avenue and the spires of the Central Congregational Church (now Church of the Covenant) and the Brattle Square Church (now First Baptist). (Author's collection.)

An elegantly dressed woman sits on the edge of a granite-encircled pool in the Boston Public Garden. These picturesque stereoviews, most taken between 1860 and 1875, show how elegant the grounds were and exemplify the success in creating man-made land for both residential development as well as for a pleasure garden. In the distance are the new townhouses along Arlington Street and Commonwealth Avenue. (Author's collection.)

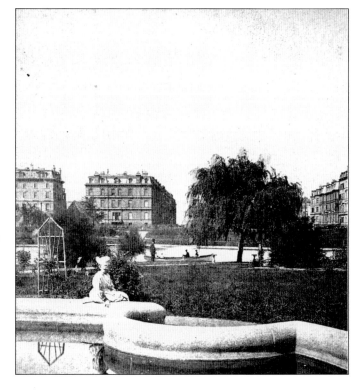

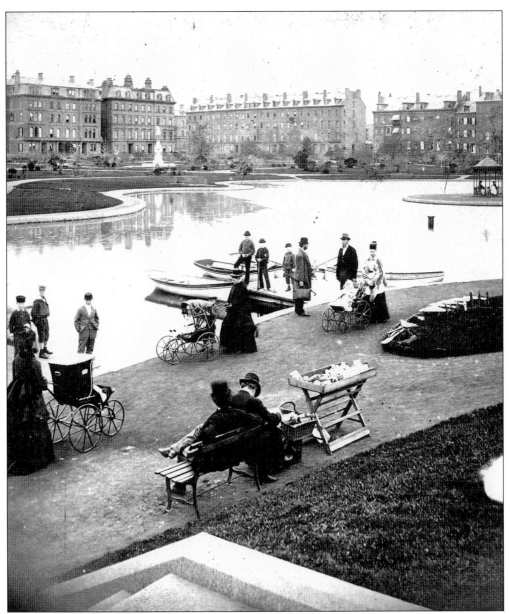

The lagoon had been laid out as an attraction in the center of the Public Garden. After 1860, rowboats could be rented for a pleasurable hour of rowing around the pond. In this view, people are standing on the wood embankment. Seen are nannies, their charges in perambulators, as well as men and boys all enjoying the afternoon. The openness of the Public Garden, along with the pavilion on the far right and Ether Monument on the left, date this view at 1868. (Author's collection.)

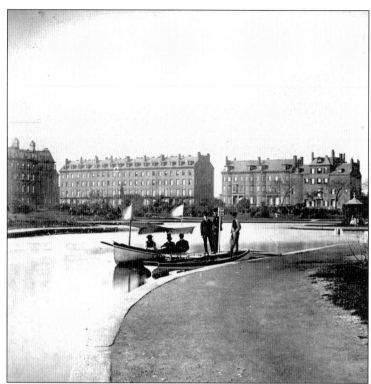

With a row of brick houses along Beacon Street acting as a backdrop, an awning-bedecked rowboat is pulled up alongside the lagoon. With its curving design, the irregularly shaped lagoon was an attractive feature that offset the straight edges of the Public Garden bounded by Charles, Beacon, Arlington, and Boylston Streets. (Author's collection.)

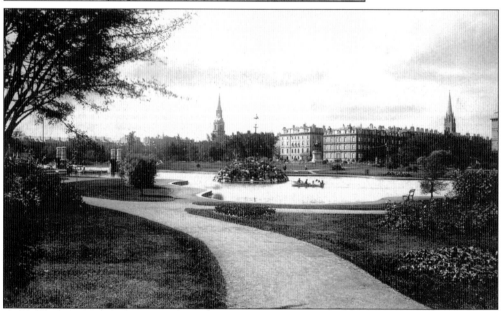

This bucolic scene from c. 1890 shows the lagoon in the foreground with the mature specimen tree plantings and flower beds. A rowboat can be seen on the lagoon, and the impressive dignity of Arlington Street, with townhouses between the Arlington Street Church (on the left) and Commonwealth Avenue, has never been more obvious. The spire on the right is the Central Congregational Church, now the Church of the Covenant. (Courtesy the Boston Public Library Print Department.)

A group of friends in a rowboat leaves the dock as vacant rowboats await passengers who will spend some time on the lagoon. (Author's collection.)

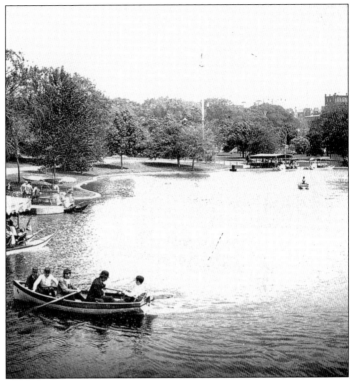

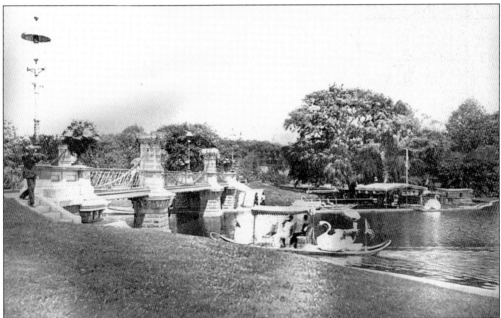

This lovely scene shows one the Paget family's swan boats on the lagoon as it is about to pass under the suspension bridge designed by William Gibbons Preston. The dock, seen on the right in the distance, had by 1895 become an active place where visitors could now enjoy a leisurely ride around the lagoon, all for a few cents. By this time, the rowboats had been retired and only the Paget family's swan boats were allowed on the pond. (Author's collection.)

In this *c.* 1900 photograph, a swan boat passes in the foreground with quite a few people enjoying their leisurely ride. By this time, the Public Garden had mature trees and plantings that created an oasis in the center of the city. In 1895, it was said in *Boston of Today* that

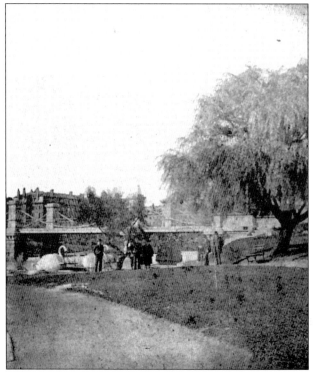

In what might be among the earliest stereoviews of the Paget family swan boats, the suspension bridge can be seen as a backdrop to what has become the enduring image most people have of the Back Bay—the swan boats. (Author's collection.)

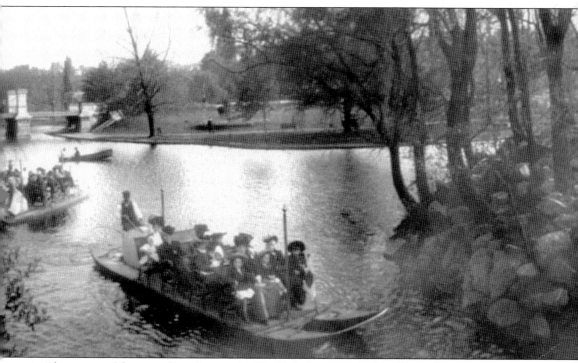

in "the season of flowers, when thousands of bedded plants are displayed in striking combination of color, it is a mass of brilliant bloom and rich verdure." (Author's collection.)

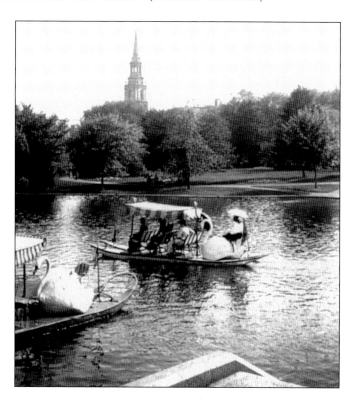

Inspired by the opera *Lohengrin*, the graceful swan boats are peddled by employees to the delight of children and adults alike. (Author's collection.)

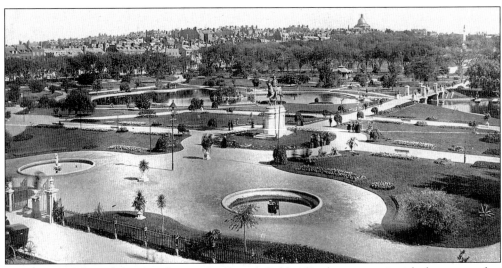

Seen in 1895 from Arlington Street, the Boston Public Garden was a virtual pleasure garden that had been created from the marshlands and former ropewalks at the edge of the Boston Common. Infilling began in the late 1830s with refuse and street sweepings, and by 1859, improvements began. They included the central body of water known as the lagoon, serpentine pathways, statue-graced fountains, and monuments such as the equestrian statue of Gen. George Washington, in the center. In the distance is the dome of the Massachusetts State House, and on the right is the spire of the Park Street Church.

William Doogue was appointed superintendent of the Boston Public Garden in 1879 by Mayor Samuel D. Cobb. He was said to be "ever willing to impart information to citizens and the many strangers who visit the [Public] Garden during the summer." It was largely due to Doogue and his capable and talented staff that the Public Garden was made into a beautiful place that was greatly appreciated by visitors.

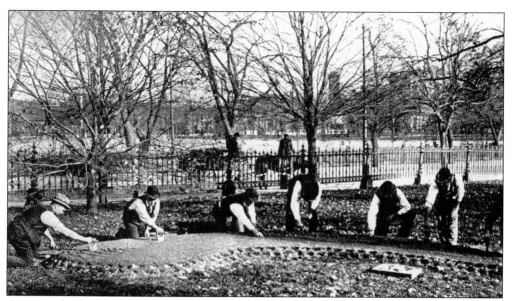

A group of city workers under the direction of William Doogue begins the planting of a flower bed with Dutch bulbs in 1893. With thousands of bulbs planted in the fall in the late 19th century, it was undoubtedly a glorious sight when they bloomed in such profusion, as they were "set out in numbers well-nigh incredible," as one writer said in 1893.

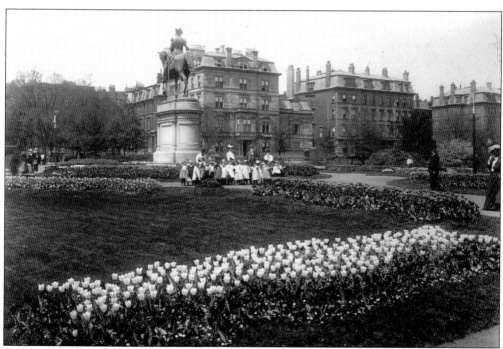

Children and their guardians gather near the Washington statue to admire the massive beds of tulips in the Public Garden in 1906. These displays, orchestrated by William Doogue and his staff, were harbingers of spring that started over six months of displays of flowers that delighted visitors. (Courtesy the Boston Public Library Print Department.)

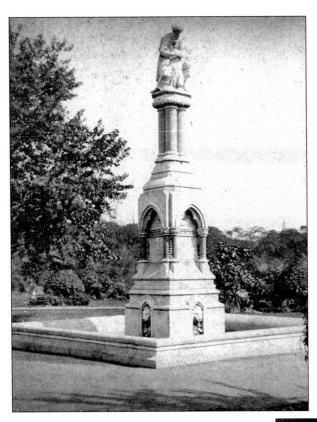

The Ether Monument in the Public Garden was designed by John Quincy Adams Ward and was the gift of Thomas Lee. Dedicated in 1868, the granite and red-marble monument with two figures, representing the story of the good samaritan, surmounting the shaft erected "as an expression of gratitude for the relief of human suffering occasioned by the discovery of the anesthetic properties of sulphuric ether." (Author's collection.)

Dr. William Thomas Green Morton, seen in a painting done in 1845 by W. Hudson Jr., was considered to be the first physician to use ether in an operation. The experiment, conducted in 1847 at the Massachusetts General Hospital in Boston, proved that the inhalation of ether causes insensibility to pain.

Edward Everett (1794–1865) was one of Boston's noblemen. The president of Harvard College, a writer, an orator, and a statesman, he was one of the most eloquent speakers of his day and presented a reading of the Gettysburg Address that was two hours in length, as compared to Abraham Lincoln's short speech. The statue was the work of William Wetmore Story and was unveiled in 1867, a gift to the city from the citizens of Boston. In 1911, the statue was relocated from the Public Garden to Edward Everett Square in Dorchester, opposite where he was born. (Author's collection.)

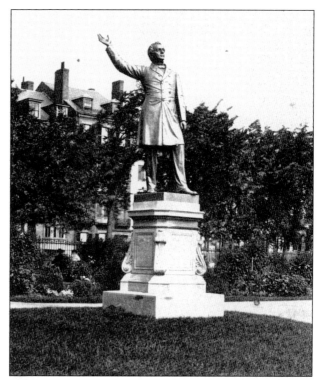

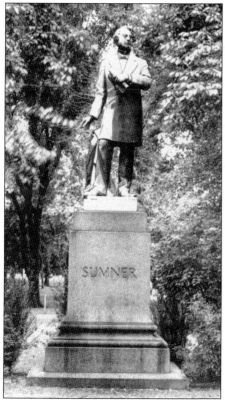

Charles Sumner (1811–1874) was a noted statesman—a U.S. senator from Massachusetts—who was a champion of emancipation in the South. Educated at Harvard and Harvard Law School, he had a brilliant career as an attorney, statesman, abolitionist, and supporter of public education. The statue is the work of Thomas Ball and was unveiled in 1878.

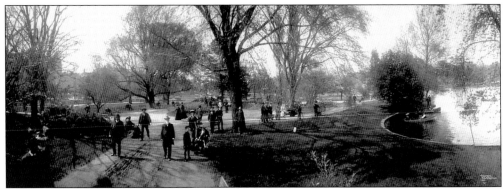

Visitors to the Boston Public Garden, seen at the turn of the century, marveled at what had been accomplished since 1859, when the first major efforts were taken by the city of Boston to create a park in the area adjacent to the infilling of the marshes of the Back Bay. Within four decades, the Public Garden had become not just a picturesque oasis within the city but a place of resort for residents, children, and visitors to the city alike. (Author's collection.)

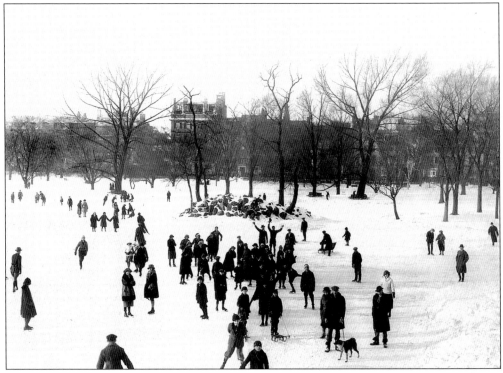

The lagoon was flooded in the winter to allow for ice-skating. This 1923 view shows skaters enjoying the activity, which has been popular since the 1850s, when Bostonians resorted to Jamaica Pond to enjoy an afternoon during the winter months. According to Edwin Bacon's *Dictionary of Boston*, the lagoon was often "covered by a gay throng of happy youth whose skates glisten in the sun and whose merry voices ring out joyously on the air." In the center, the tallest building is the townhouse of Bayard Thayer. It was designed by Ogden Codman and built in 1911. This was the setting for the popular television show *Cheers*. (Courtesy the Boston Public Library Print Department.)

Two

GILMAN'S VISION

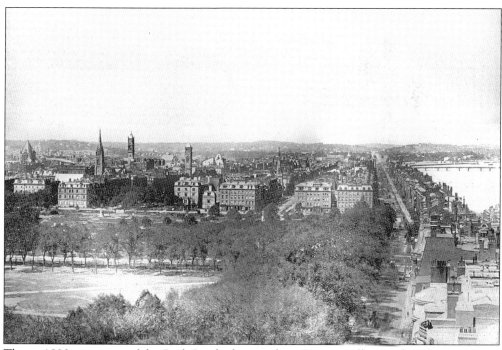

This c. 1890 panorama of the Back Bay looks west from Beacon Hill's Hotel Tudor on Beacon Street. Seen is the area between Boylston Street, on the left, and Beacon Street, on the right, past the Boston Public Garden. The uniform height of the townhouses was punctuated by church spires. From left to right, the spires are those of the Trinity, Covenant, Old South, First Baptist (formerly Brattle Square), and First Churches in Boston.

The projected development of the Back Bay was drawn in 1825 by Abel Bowen for Caleb Snow's *A History of Boston*, showing row houses with a uniform height, set back, and with cross streets that included a center treelined space that eventually came to reality. On the left is a church, which was eventually built in 1860 as the Arlington Street Church. It is remarkable that this design was to come to fruition three decades later.

Abel Bowen was a noted engraver of copperplate and woodcut scenes and the publisher and illustrator of Caleb H. Snow's *A History of Boston* in 1825. He was trained as an apprentice in the printing business by his uncle Daniel Bowen.

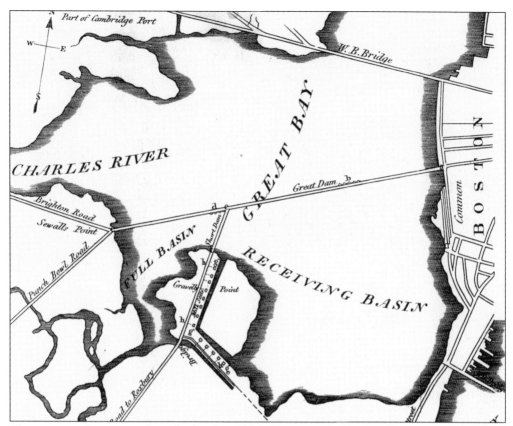

The receiving basin was a large body of marshland between the Boston Common, on the right, and Gravelly Point, the area of the present Fenway. The Great Dam, seen in the center, was laid in 1821 from Boston to Brookline as a toll road and is the present-day Beacon Street.

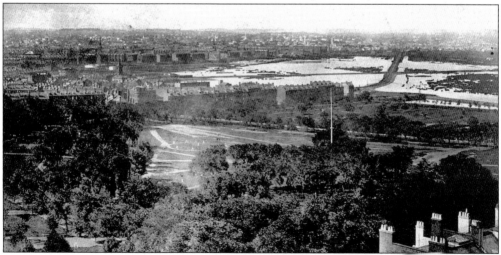

This c. 1855 view from the dome of the Massachusetts State House shows the Boston Common in the foreground. The common was open land shared in common by residents of Boston since 1630, when settled by the Puritans. In the distance is the Back Bay, with the crossroad of the Boston and Providence Railroad leading from the Park Square Depot.

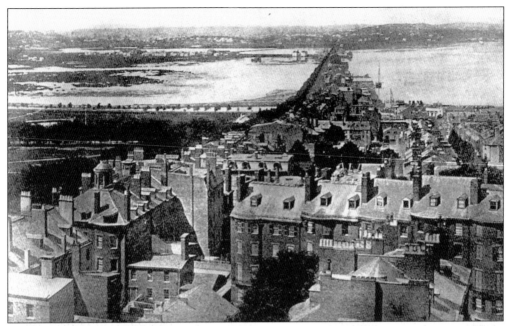

In this c. 1855 view looking west from the dome of the Massachusetts State House, Beacon Street (the former Mill or Great Dam) leads from Boston to Brookline at Sewall's Point. On the left, the edge of the Boston Common is marked by trees. The marshlands of the Back Bay are seen beyond. In the center distance are two mills on Parker (now Hemenway) Street.

John Souther (1816–1911) was a native of South Boston and owner of the Globe Locomotive Works. An engineer, he was a mechanical genius and was commissioned by the Commonwealth of Massachusetts to develop a variety of machinery for carrying out what was considered the greatest national enterprises and public improvements of the 19th century. He was lauded for a steam shovel that allowed fill to be easily transported to the Back Bay.

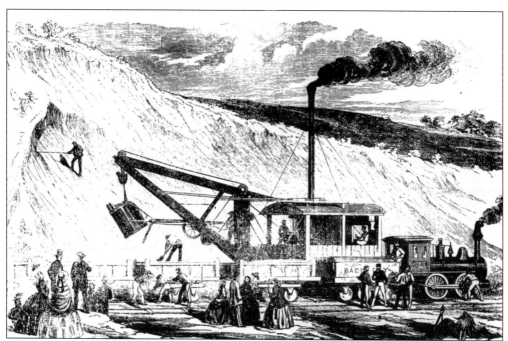

The Souther steam shovel, seen in an illustration from Ballou's 1858 *Pictorial Drawing Room Companion*, shows gravel and soil from Needham being dredged and dumped into flatbed cars on the railroad that had 35 cars that arrived on average once an hour, six days a week, for almost four decades. Enough fill was transported that two house lots per day could be completed.

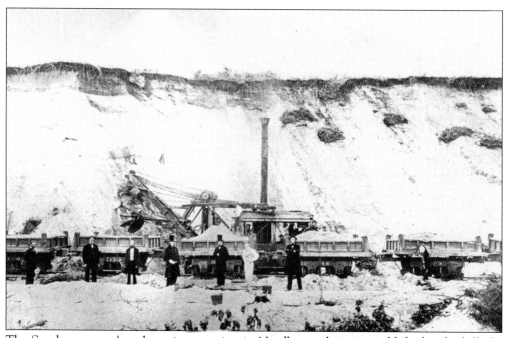

The Souther steam shovel was in operation in Needham, where it would dredge the hills for gravel and fill that was loaded into open tip cars that would travel to the Back Bay continually, with a reputed rate of over 3,000 carloads of fill a day being transported.

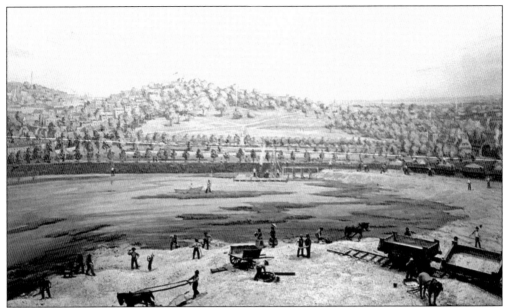

In a diorama of the infilling project, the gravel-filled cars can be seen on the right where they would be tipped by a spring action to dump their fill into the marshes to be spread by the workers. This process, which began in the late 1850s, would continue unabated for the next three decades, creating over 450,000 square feet of man-made land that was developed as the quintessential Victorian neighborhood of Boston.

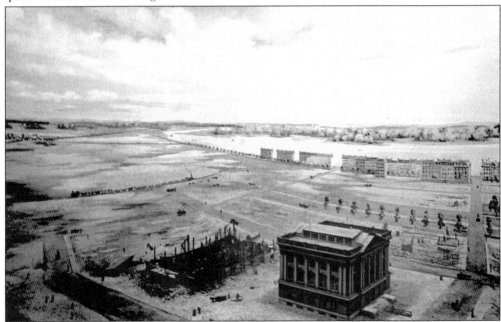

In a c. 1863 diorama of the Back Bay, the New England Museum of Natural History can be seen on the lower right with the foundations being laid for the Rogers Building of the Massachusetts Institute of Technology on the left. The area of the Back Bay had been infilled as far as Dartmouth Street by this time, though only Beacon Street, seen in the distance, and Arlington Street had houses built.

Three

PLACES OF WORSHIP

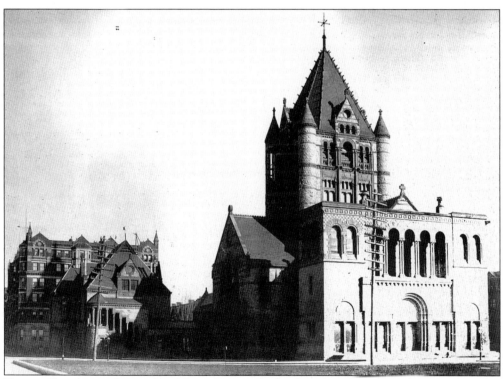

Trinity Church was designed by Henry Hobson Richardson (1837–1886) and is considered his greatest and most enduring masterpiece. Seen from Boylston Street, the church was inspired by the Romanesque churches of Auvergne and Salamanca and was consecrated in 1877. On the left is the chapel of Trinity Church, and the Hotel Brunswick is in the distance.

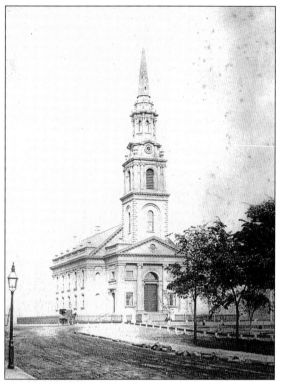

The Arlington Street Church was designed by Arthur Gilman and built in 1860 at the corner of Arlington and Boylston Streets. The congregation, originally known as the Federal Street Church, had originally worshiped on Federal Street in downtown Boston. As that area became increasingly commercial, they commissioned a new church to be built of brownstone in the emerging Back Bay. This photograph, taken shortly after the church was completed, shows the Public Garden on the right. Nothing had been built beyond the church.

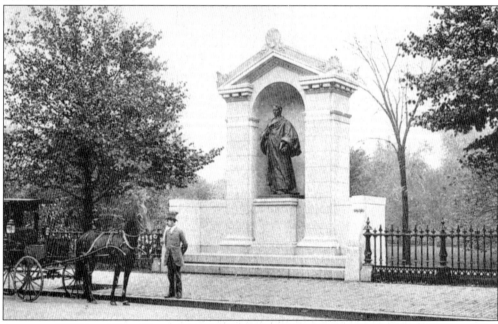

A statue of William Ellery Channing, minister of the Federal Street Church from 1803 to 1842, was placed opposite the Arlington Street Church, the former's successor, on the edge of the Boston Public Garden. The work of Herbert Adams, it was the gift of John Foster, a parishioner of the church. It was said of Channing by Rev. Theodore Parker, "His word sank into men as the sun into the ground to send up grass and flowers." (Author's collection.)

The First Church of Boston was designed by Ware and Van Brundt and built in 1867 at the corner of Berkeley and Marlborough Streets. The church, seen in 1880 bedecked with bunting in honor of its 250th anniversary, was built of Roxbury puddingstone and brownstone trim in the English Gothic style, with a fine carriage porch on the side. Today, it is known as First and Second Church in Boston, as the two oldest churches in the city eventually merged.

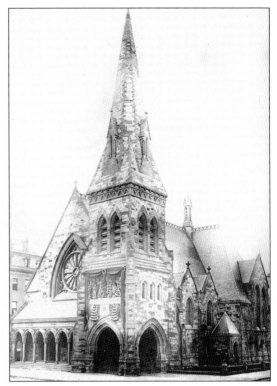

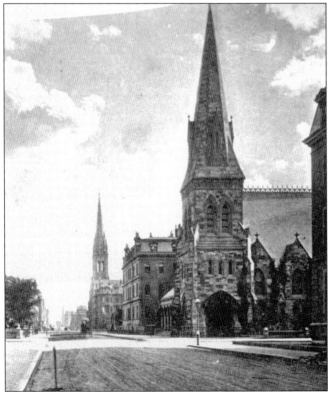

Berkeley Street, seen from Beacon Street, was primarily a residential street with two impressive churches. On the right is the First Church in Boston, at the corner of Marlborough Street, and in the center is the Central Congregational Church (now the Church of the Covenant) at Newbury Street. On the left are the Minot house, designed by Snell and Gregerson and built in 1865, and the Phillips House, designed by Peabody and Stearns and built in 1877. (Author's collection.)

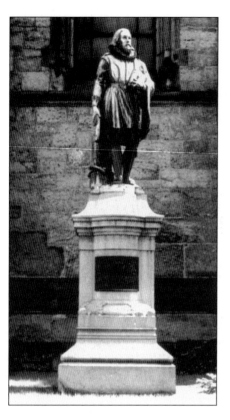

A statue of John Winthrop by Richard Saltonstall Greenough was placed on the grounds of the First Church when it was removed from Winthrop Square in the West End. The first governor of the Massachusetts Bay Colony, Winthrop, in the *Arbella,* led a fleet of ships carrying Puritans seeking religious freedom. They settled Boston, building "the City upon a Hill."

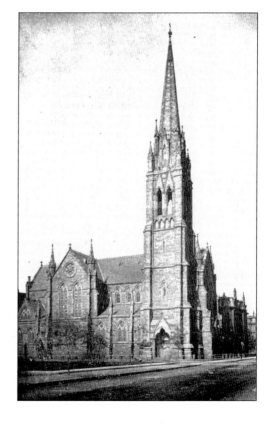

The Central Congregational Church was designed by Richard M. Upjohn and built in 1866 at the corner of Berkeley and Newbury Streets. Built of Roxbury puddingstone with sandstone trimming, its 236-foot spire was once the tallest in the city. Founded in 1835, the congregation moved to the Back Bay from Winter Street, where they had worshiped since 1841. Today, this is the Church of the Covenant.

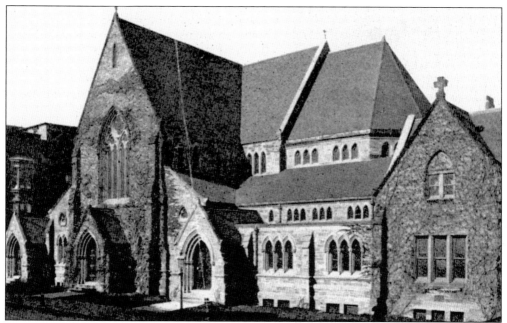

Emmanuel Church was designed by A.R. Estey and built in 1862 on Newbury Street between Arlington and Berkeley Streets. Founded in 1860, the congregation was among the wealthiest in the city in the 19th century. Built of Roxbury puddingstone in the Gothic style, the church was unfortunately hemmed in on either side by residences and never made an impact on the streetscape.

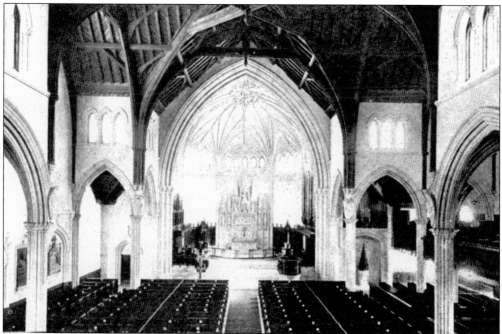

The interior of Emmanuel Church was considered to be rich and brilliant, with highly carved black oak woodwork and pews and a white-marble communion rail that gave both a contrast of color as well as the union of strength and delicacy.

41

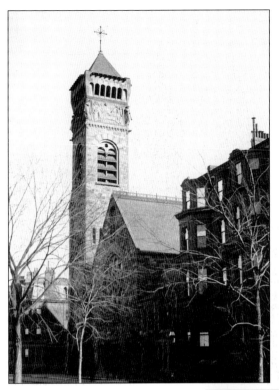

The Brattle Square Church was designed by H.H. Richardson and built in 1871 at the corner of Commonwealth Avenue and Clarendon Street. The congregation once worshiped in the old West End. It moved to the Back Bay, where most of the members lived. Built of Roxbury puddingstone, the church is distinguished by a tall bell tower that has a large frieze in bas-relief by the noted sculptor Frederic A. Bartholdi. The design represents baptism, communion, marriage, and burial, with angels blowing trumpets on the four corners that have given rise to the appellation "the Church of the Holy Bean Blowers." The church became the First Baptist Church in 1881.

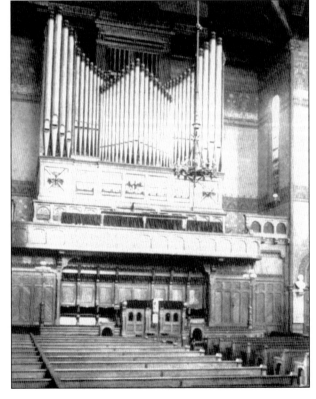

The interior of the First Baptist Church was extensively altered in 1881, only a decade after the church was built. New galleries were built in the transepts, and a new choir gallery was constructed. The massive pipe organ, seen here in the early 20th century, was a magnificent instrument.

The New Hollis Street Church was designed by George T. Meacham and built in 1883 at the corner of Newbury and Exeter Streets. Founded in 1730, the church moved from Hollis Street and commissioned a red-brick, freestone, and terra-cotta church in the Byzantine style. The corner tower was a round base with a 12-sided cap. The church later became the Copley Methodist Episcopal Church. It was demolished in 1966. On the left is the tower of the New Old South Church.

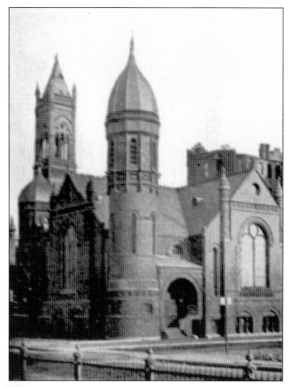

Rev. Edward Everett Hale was so beloved by his congregation at the New Hollis Street Church that it was often referred to as Dr. Hale's Church. Reverend Hale had been minister of the South Congregational Society, which merged with Hollis Street, and he had an international reputation as a leader in religious and social thought. He served as chaplain of the U.S. Senate. The author of *A Man without a Country*, Hale was a resident of Roxbury and a nephew of the great statesman Edward Everett.

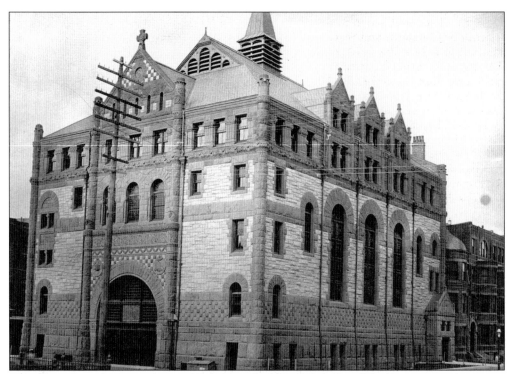

The spiritualist temple was designed by Hartwell and Richardson and built in 1884 at the corner of Dartmouth and Newbury Streets. It was known as the meetinghouse of the Working Union of Progressive Spiritualists. Built through the generosity of Marcellus Ayer, a wealthy Boston merchant, it is in the Romanesque style and was built of variegated colors of brownstone. It has an interesting facade that includes carvings above the entrance. The temple was later used as the Exeter Street Theater.

The side entrance porch of the spiritualist temple was on Newbury Street. Architects H.W. Hartwell and W.C. Richardson used rough-hewn quarry-faced granite that was combined with highly and delicately carved brownstone for capitals and a frieze that offset the rough texture of the walls.

The New Old South Church was designed by Cummings and Sears and built in 1874 at the corner of Boylston and Dartmouth Streets. Having worshiped since 1669 on Washington Street in downtown Boston, the congregation moved to the Back Bay and commissioned this Northern Italian Gothic design with a massive stone campanile, or bell tower. Built of Roxbury puddingstone with brownstone and freestone dressings, the church is an impressive example of high-Victorian architecture. (Author's collection.)

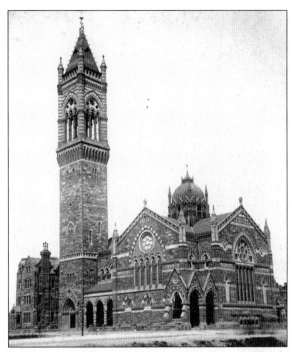

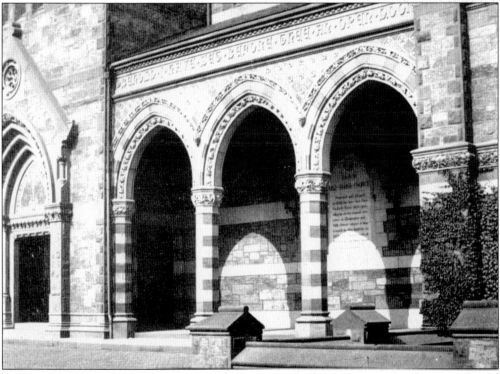

The porch of New Old South Church has an arcade with alternating pieces of brownstone and freestone that create a varied and highly ornamented design. Colonial slate headstones are set in the wall, and above, across the front, are carved the words "Behold, I have set before thee an open door."

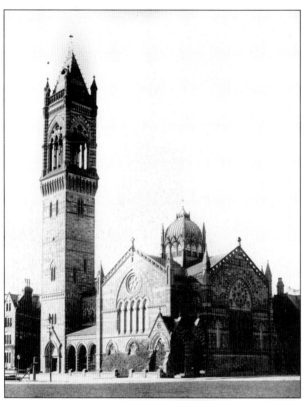

Seen from Copley Square, the New Old South Church commands the corner of Boylston and Dartmouth Streets, and its gilded copper lantern is 20 feet square and caps the intersection of the arms of the cross. The campanile, with its pyramidal spire, was one of the tallest in the Back Bay, but due to its immense weight, it had begun to settle and was rebuilt in the 1930s in a shorter and simpler form.

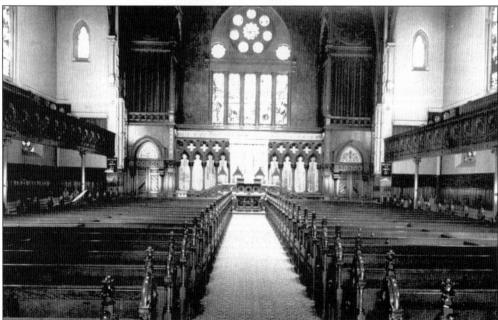

The interior of New Old South Church is finished in cherry and is brilliantly frescoed. It had an open timber roof with tie-beam trusses with arched braces. The pulpit is backed by a high carved-wood screen, and above it, seen here, is an imposing stained-glass window that represents the announcement to the shepherds of the birth of Christ. (Author's collection.)

The Mount Vernon Congregational Church was designed by Walker and Kimball and built in 1891 at the corner of Beacon Street and Massachusetts Avenue. On the right is 490 Beacon Street, designed by E.N. Boyden and built in 1892 as speculative property for E.H. Fay. Today, the former church has been converted to condominiums. (Author's collection.)

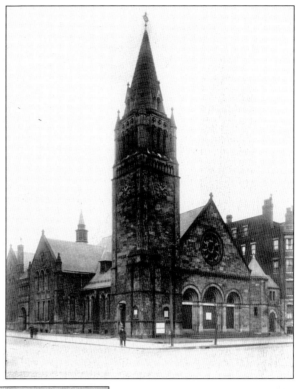

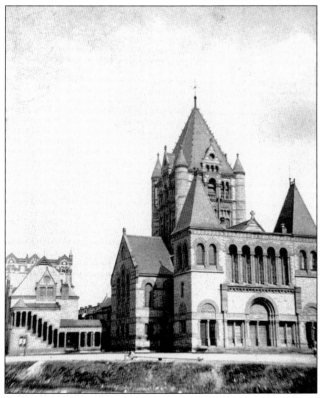

Trinity Church, seen in a stereoview from 1880, was designed by H.H. Richardson in the pure French Romanesque style in the shape of a Greek cross. Built of Dedham granite and ornamented with brownstone trim, it was consecrated in 1877, five years after its location at Summer and Hawley Streets in downtown Boston was destroyed in the Great Boston Fire of 1872. On the left is the chapel. (Author's collection.)

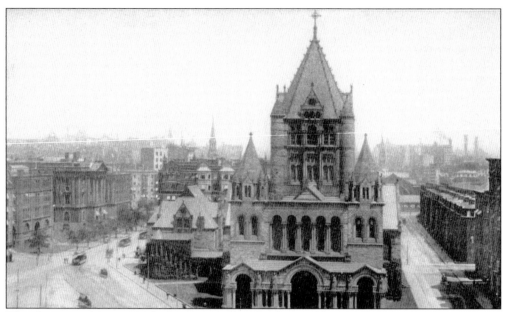

This dramatic photograph shows Trinity Church, designed by Shepley, Rutan, and Coolidge, as the dominant structure, with the western porch added in 1898 and the towers lowered and changed. H.H. Richardson of Boston and Gambrill of New York were the architects, though the former usually receives sole credit, and were succeeded by the architectural firm of Shepley, Rutan, and Coolidge. The massive tower, which is 211 feet high, is 46 feet square.

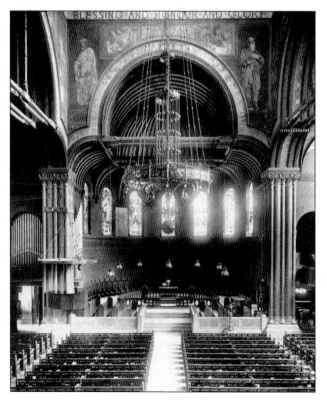

The nave of Trinity Church is as solemn as it is dignified. The whole interior of the church is finished in black walnut, and the vestibule is finished in ash and oak. It was said in Edwin Bacon's *Dictionary of Boston* that the "interior decorations are elaborate and in exquisite taste, and they form an endearing monument to the skill of John La Farge of New York." La Farge created a far bolder vision than the stark meetinghouses of Boston a half a century before.

Rev. Phillips Brooks preached his first sermon at Trinity Church in 1869. Not just a respected clergyman, he was said to be filled with a sincere compassion and possessed of a talent for expressing for every man the gospel of Jesus Christ.

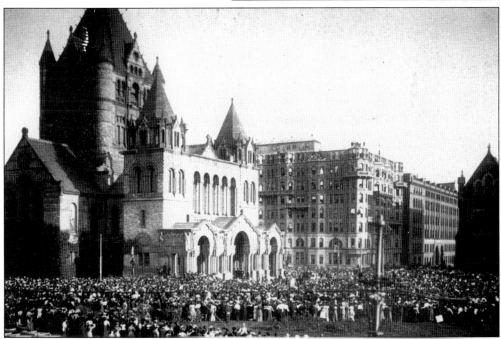

The funeral of Rev. Phillips Brooks was held at Trinity Church on January 26, 1893, and was officiated by Rev. E. Winchester Donald. Literally thousands paid their last respects to Brooks, who served as bishop of the Episcopal diocese of Massachusetts at two funeral services. In the distance can be seen the Hotel Westminster.

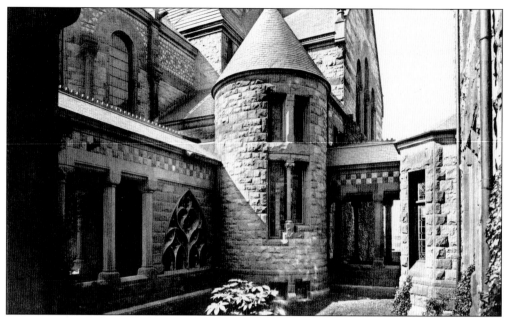

The cloister of Trinity Church is a juxtaposition of architectural elements from the covered open cloister on the left, the rounded turreted bay, and the massive lantern above which surmounts the center of the roof. The tracery window, to the left of the turret, was brought from St. Botolph's Church in Boston, England.

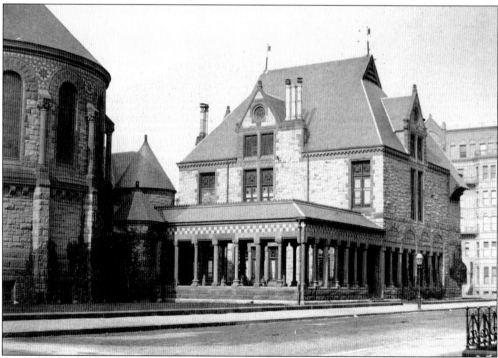

The chapel of Trinity Church is connected to the main structure by an open cloister, which creates a striking effect in the use of granite and brownstone. The chapel, and the semicircular apse at the eastern arm of the church, adds great character to Clarendon Street.

50

Four

BACK BAY INSTITUTIONS

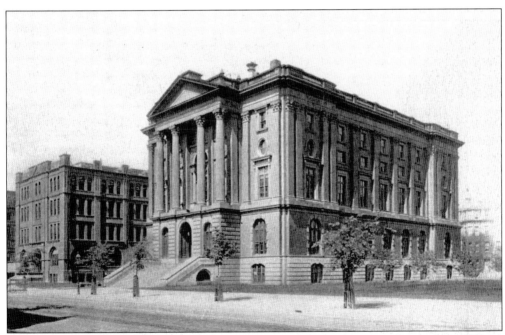

The Rogers Building of the Massachusetts Institute of Technology was designed by William Gibbons Preston and built in 1863 on Boylston Street, between Berkeley and Clarendon Streets. Named for William Barton Rogers (1804–1882), the founder and first president of the college, the building was impressive in its design. By c. 1900, MIT had created an urban campus that would become well known. After 1916, the institution moved to Cambridge, overlooking the Charles River. (Author's collection.)

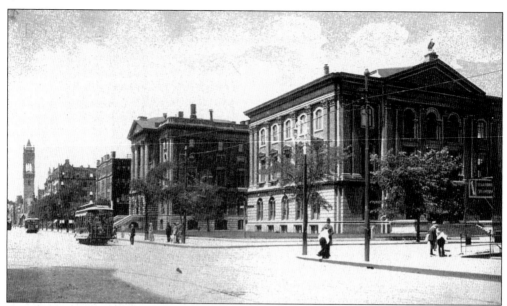

In this view looking west from the corner of Berkeley and Boylston Streets, the New England Museum of Natural History is on the right. The Rogers and the Walker Buildings of the Massachusetts Institute of Technology are on Boylston Street. The natural history museum, organized in 1830, commissioned William Gibbons Preston to design their museum, built in 1862 in a classical French Academic style. The building is now home to Louis Boston. (Author's collection.)

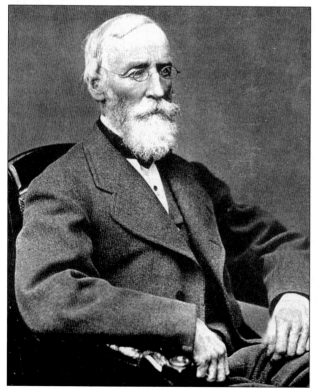

Jeffries Wyman (1814–1874) was president of the Boston Society of Natural History when the new museum was built in 1862. Wyman had been curator of the mammals, reptiles, and fish exhibits for over a decade, and he was instrumental in securing William Gibbons Preston, a resident of 16 Arlington Street in the Back Bay, to design the new museum.

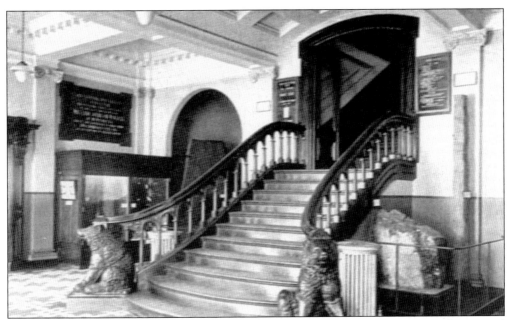

The entrance hall of the natural history museum was an impressive space with a grand mahogany staircase that had large seated bears carved of mahogany that served as fanciful newel posts. Exhibits were spread throughout the building and included specimens of rock, seen on the right, as well as reptile eggs, on the left in a cabinet.

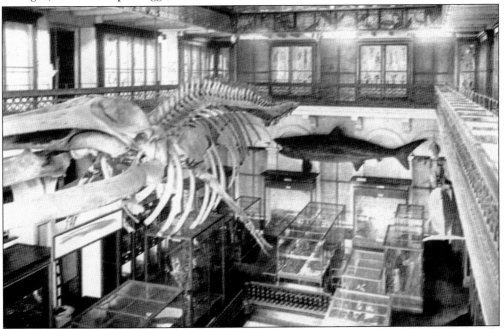

The main gallery of the museum was a two-story space with glass display cases of mammals, fish, and reptiles and large skeletons of mammals suspended from the ceiling. The galleries had display cases along the balcony, which offered both children and adults many pleasurable hours. Today, the museum is known as the Museum of Science. Since 1949, it has been located on the Charles River basin.

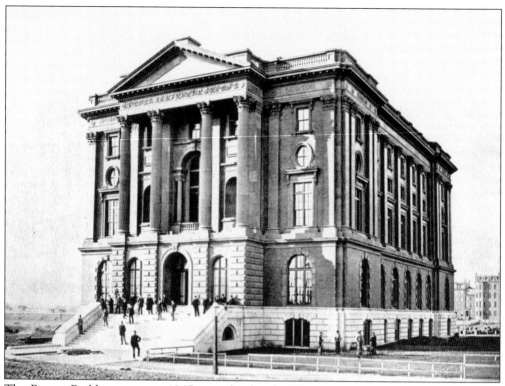

The Rogers Building, seen in 1865, was the first building of the Massachusetts Institute of Technology, which had been incorporated in 1861. Designed by William Gibbons Preston, it was set on a rusticated foundation with a classical French Academic design, including four monumental Corinthian columns supporting a pediment. The Rogers Building was demolished in 1939 for the New England Mutual Insurance Company, now known as the New England.

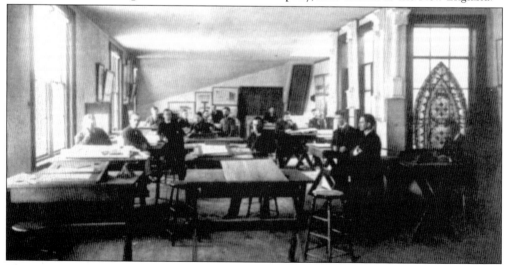

The Massachusetts Institute of Technology, under the direction of William Rotch Ware, was to establish the first school of architecture in the United States. Prior to this time, one might study abroad at the Ecole des Beaux Arts in Paris. This view shows a group of architectural students in the drafting room of the Rogers Building.

Seen from Clarendon Street, the Rogers Building was similar in design to the natural history museum, but it was massive, with four floors above a basement. Seen in this 1870 view, the building was to provide a technical, engineering, and architectural education to students, which was the goal of William Barton Rogers, who also served as president of the Association for the Advancement of Science. (Author's collection.)

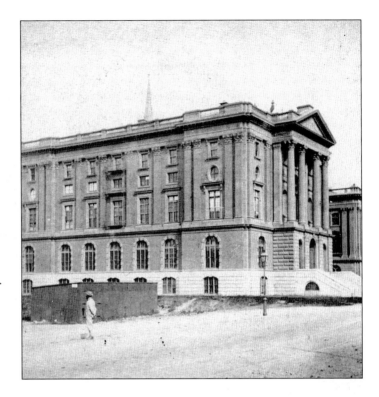

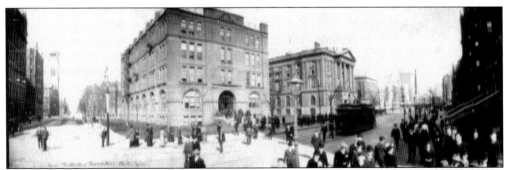

Boylston Street, seen from Clarendon Street, is a bustling scene in this 1903 photograph. On the left is the Walker Building, and next to it is the Rogers Building. In the distance is the natural history museum. A streetcar travels along Boylston Street, but within a decade, it would be suppressed underground with the Boylston Street subway, which connected Tremont Street and Massachusetts Avenue. (Author's collection.)

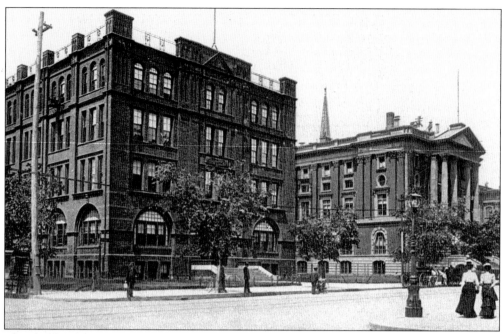

The Walker Building, on the left, was quite different than the Rogers Building of the Massachusetts Institute of Technology. It was designed by Carl Fehmer and built in 1883 for such laboratories as electrical engineering and applied mechanics. The Walker Building was built less than two decades after the Rogers Building but was very different in its architectural style. (Author's collection.)

William J. Walker (1789–1865) of Newport, Rhode Island, was a generous benefactor of the Boston Society of Natural History as well as the Massachusetts Institute of Technology. His generous bequest to MIT enabled the construction of the Walker Building, which was named in his honor.

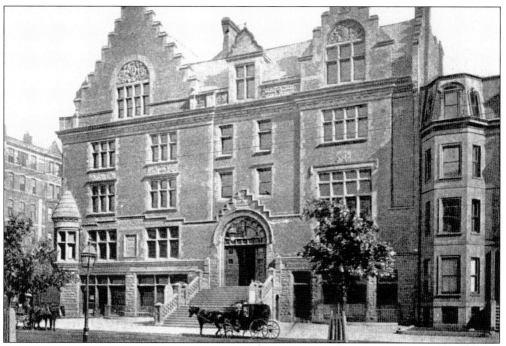

The Boston Young Men's Christian Association (YMCA) was designed by Sturgis and Brigham and built in 1883 at the corner of Boylston and Berkeley Streets. An interesting building in what was called the Scotch Baronial style, it had stepped gables with banks of windows that created an eclectic design. On the right is the Craft house, built in 1875.

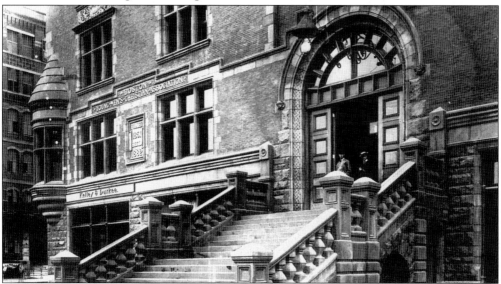

The facade of the YMCA building had a sweeping staircase that ascended from Boylston Street to an arched entrance. Here, young men were encouraged to pursue good health through exercise, and Dean Samuel S. Curry, the later founder of Curry College, conducted classes in the school of expression on the second floor. On the third floor was the Chauncy Hall school, a private coeducational school founded in 1828 in downtown Boston that had sold its school in 1908 at 585 Boylston Street. (Author's collection.)

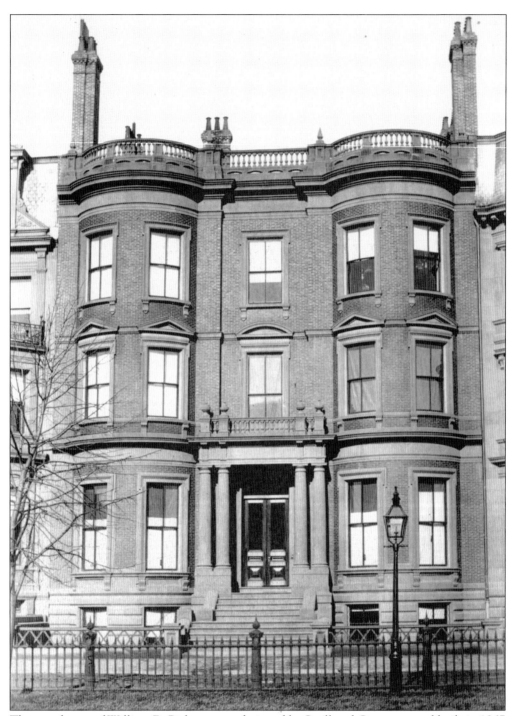

The townhouse of William D. Pickman was designed by Snell and Gregerson and built in 1867 at 15 Commonwealth Avenue. A double swell-bay facade, it has a center entrance with paired Doric columns and a foundation of brownstone, and the building is of red brick. The classical aspects of the design include symmetry, pedimented lintels, and a roof balustrade, all restrained but elegant in the design. (Courtesy the Boston Public Library Print Department.)

Five

THE BACK BAY

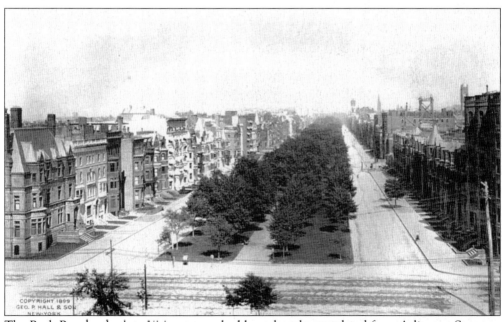

The Back Bay, by the late 19th century, had been largely completed from Arlington Street to the Back Bay Fens, the area formerly known as Muddy River. Seen here in a photograph from 1899, Massachusetts Avenue bisects Commonwealth Avenue with the mall in the center. This treelined mall extended from opposite the Public Garden and was part of Olmsted's Emerald Necklace, which encircled the city with green space.

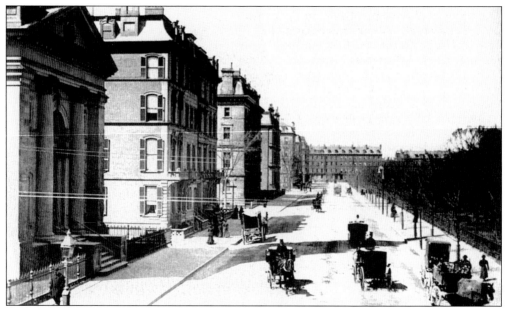

Arlington Street, seen from Boylston Street in the 1890s, was the first street west of the Public Garden, which can be seen on the right. On the left is the facade of the Arlington Street Church, which moved from Federal Street in downtown Boston to this site in 1860. On the right is the Benjamin Bates house, at 19 Arlington Street, built in 1864. The uniformity of roof height, which added to the overall design of the Back Bay, is evident in this photograph.

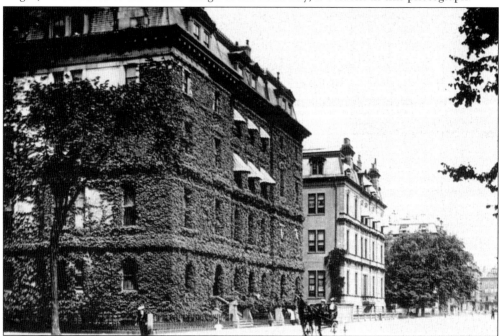

The ivy-covered townhouse of Dr. Henry H. Williams, one of three houses designed by Richard Morris Hunt and built in 1860, can be seen at the corner of Arlington and Newbury Streets. The aspect of three individual houses sharing a mansard roof gave a more imposing feel to the overall design. On the right is the side of the James Little house at 2 Commonwealth Avenue.

The home at 12 Arlington Street, at the corner of Commonwealth Avenue, was designed by Edward Clarke Cabot and built in 1860 for John Bates. A four-story townhouse built of brownstone, it was later the home of J. Montgomery Sears. In 1893, Sears purchased 1 Commonwealth Avenue directly behind his townhouse and created a massive residence where he and his wife, Sarah Choate Sears, amassed an art collection and hosted musicals by noted masters and artists who she patronized.

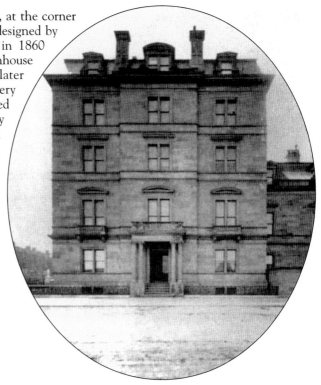

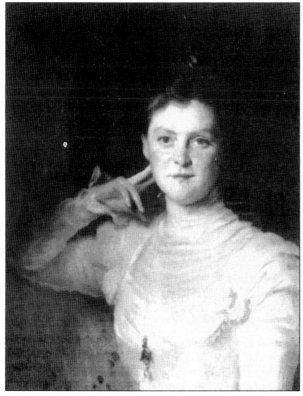

Sarah Choate Sears (1856–1935) was a prominent Back Bay hostess whose townhouse held an impressive art collection, including Edouard Manet's painting *The Street Singer*, which is now in the collection of the Boston Museum of Fine Arts. She was painted by John Singer Sargent, with her daughter Helen, in the Dutch Room of Fenway Court, the home of her friend and fellow art collector Isabella Stewart Gardner.

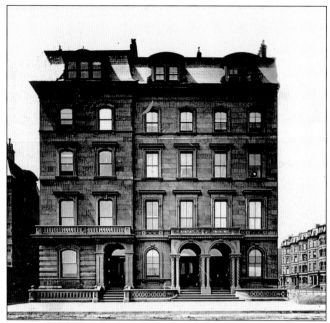

These three townhouses, 11 (left), 10 (center), and 9 Arlington Street, were built in 1861 for the Homans, Cazenove, and Brewster families. Though not designed as a unit, the two on the right share symmetrical designs, including a paired entrance with columns supporting an arch. They are of the popular building material known as brownstone, which quickly eclipses red brick in this period as the building material of choice. On the right are townhouses on Marlborough Street.

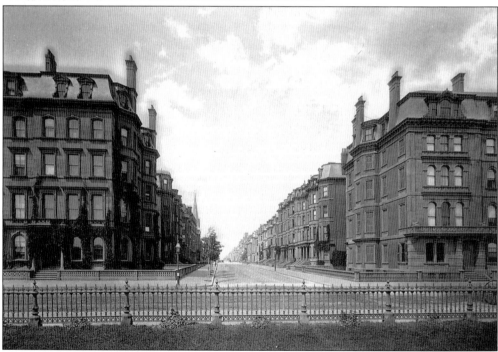

In this 1880 photograph taken from the Boston Public Garden, the townhouses on Arlington Street flank Marlborough Street. On the left is 8 Arlington Street, the Barney Corey house, built in 1870; on the right is 7 Arlington Street, the William Lawrence house, built in 1861. Marlborough Street, named after a Colonial street in downtown Boston, was built-up with houses in this block in the 1860s, including 9, 11, 13, and 15 Marlborough Street, seen on the right, designed by Charles Kirby and built in 1863. (Courtesy the Boston Public Library Print Department.)

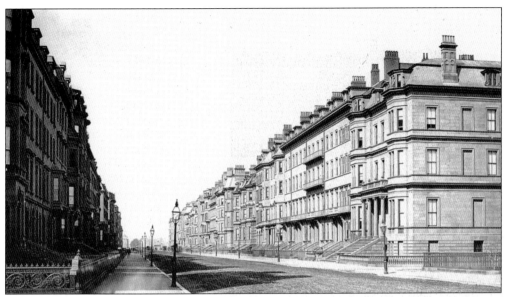

Beacon Street, originally known as the Mill Dam, had been laid out in the 1820s as a toll road to Brookline, connecting the city to Sewall's Point. Seen here in a view looking from Arlington Street, the streetscape was uniform in height and set back and created the vision Arthur Gilman had of the new Back Bay of Boston. On the right is a duplex townhouse at the corner of Embankment Road designed by Arthur Gilman and built in 1856. (Courtesy the Boston Public Library Print Department.)

John Lowell Gardner was a wealthy financier in Boston who, with his wife, Isabella Stewart Gardner, amassed a fantastic art collection that graced their Back Bay townhouse at 152 Beacon Street. The house, a gift from David Stewart to his daughter and her husband, was built in 1860 and was among the earliest to be built. Following Gardner's death, his widow built Fenway Court, a mansion later to become the Isabella Stewart Gardner Museum.

The Russell house and the Gibson House were designed by Edward Clarke Cabot and built in 1860 at 135 and 137 Beacon Street. The Russells and the Gibsons were closely related and their similarly designed townhouses shared brownstone and red-brick facades and second-floor oriels. Today, the Gibson House is preserved as a Victorian house museum and is also, appropriately, the headquarters of the Victorian Society in America New England chapter.

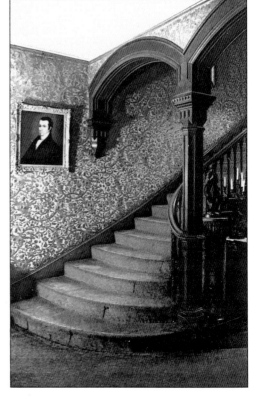

The entrance hall of the Gibson House is a larger-than-usual entry, running the full width of the house with rich mahogany woodwork. The family, which lived in the house for three generations, added faux-gilt leather-embossed wallpaper in the late 19th century. Seen here, the "Ambassador's Staircase," as Charles Hammond Gibson called it, ascends to the music room and library. The portrait is of Abraham Gibson, an ancestor of the family.

Charles Hammond Gibson, the grandson of Catherine Hammond Gibson who built 137 Beacon Street, was to ensure that the Gibson House was preserved as a museum upon his death. Seen here in a 1902 photograph, he had attended the Massachusetts Institute of Technology for a year and maintained a lifelong interest in architecture. The author of two travel books, he was also a noted poet and member of the Boston Authors Club.

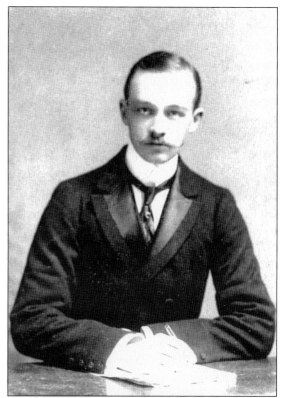

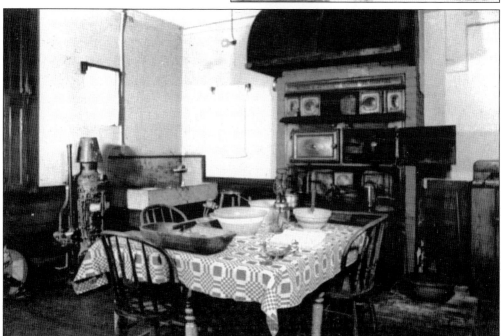

The kitchen of the Gibson House is a rare survivor of a once common room in the Back Bay. The coal range was original to the house, and the soapstone sink in the corner survives. The table and kitchen utensils are important relics that show the domestic side of this Victorian house.

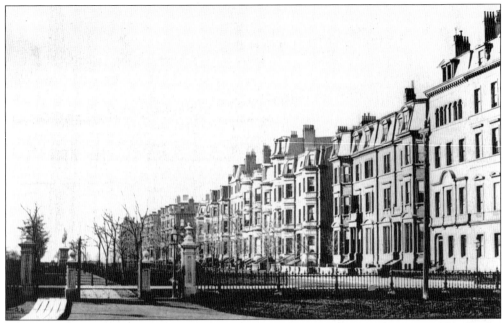

The north side of Commonwealth Avenue, west of Arlington Street, is shown in 1870. On the far right is the Bates house (at 1 Commonwealth Avenue), designed by Edward Clarke Cabot, and to its left are 3 and 5 Commonwealth Avenue, the Rotch and Lawrence houses.

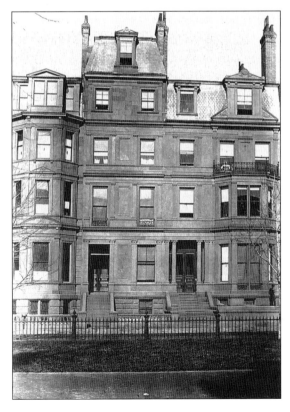

The T.C. Amory house, on the left, was built in 1867 at 19 Commonwealth Avenue, and the William H. Gardiner house, on the right, was built in 1866 at 17 Commonwealth Avenue. (Courtesy the Boston Public Library Print Department.)

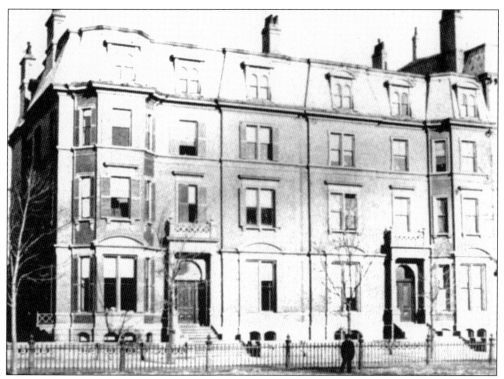

The Abbott Lawrence house, on the left, and the Benjamin Smith Rotch house, on the right, were built in 1861 at 5 and 3 Commonwealth Avenue, respectively.

Benjamin Smith Rotch (1817–1882) was a wealthy patron of the arts who had lived abroad for a number of years. His wife was Annie Bigelow Lawrence Rotch, and her parents kept their townhouse next door. Upon his death, his children established the Rotch Traveling Scholarship for aspiring architects, and his daughter Annie Rotch Lamb commissioned her brother Arthur Rotch to design the Church of the Holy Spirit in Mattapan in memory of their father.

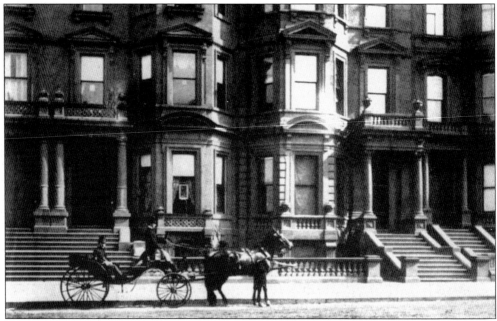

The houses at 8 Commonwealth Avenue, on the far left, and 10 Commonwealth Avenue, behind the carriage, were built in 1864 by the Bigelow and Appleton families. Impressive examples of the French Second Empire, they were built of the then fashionable brownstone. Thomas Gold Appleton sits in front of his townhouse in his carriage.

Thomas Gold Appleton was a scion of a wealthy Boston Brahmin family that derived their fortune from the Lowell and Lawrence textile mills. A noted wit, painter, and author, he coined the term "Cold Roast Boston." (Author's collection.)

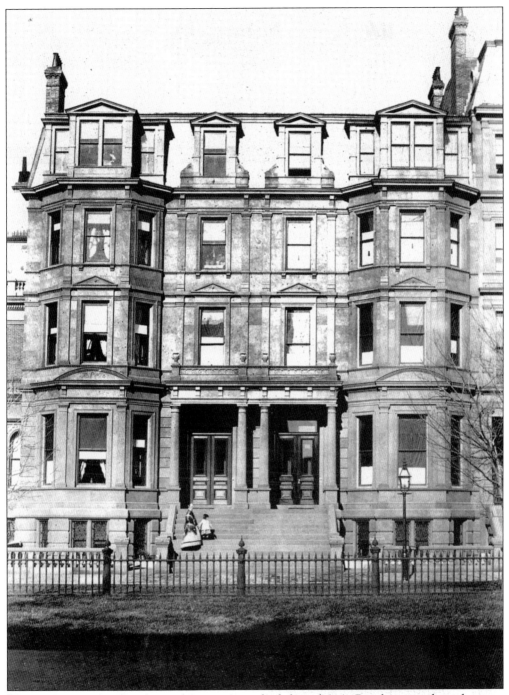

The duplex townhouses of Daniel Spooner, on the left, and A.A. Burnham, on the right, were built in 1868 at 23 and 21 Commonwealth Avenue, respectively. These houses were mirror images, with a shared entrance with Doric columns of brownstone, octagonal projecting bays, and a mansard roof. (Courtesy the Boston Public Library Print Department.)

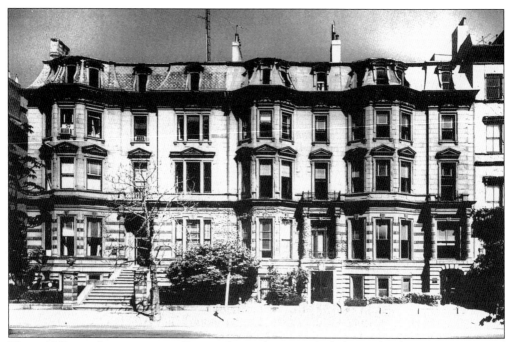

These 1861 townhouses were on Beacon Street, between Berkeley and Arlington Streets, and were designed by George Snell. On the right is 126 Beacon Street, built for John Jeffries, later the townhouse of Horatio Appleton Lamb and his wife, Annie Rotch Lamb. Built in the French Academic style, they share architectural details and a mansard roof. However, they are unique in their individual design.

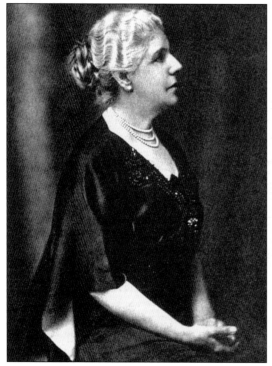

Annie Lawrence Rotch Lamb (1857–1950) was the wife of a prominent financier and the daughter of Benjamin Smith Rotch. A formidable Back Bay lady, she inherited her father's Milton estate, Pine Tree Brook, and used it in the spring and fall. Confident of her social position, she eschewed inclusion in the *Social Register,* as she said she already knew who her neighbors were.

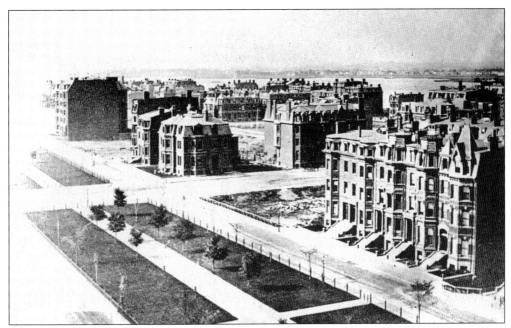

As seen in this 1877 view looking west on Commonwealth Avenue at Dartmouth Street from the tower of the Brattle Square Church, the Back Bay saw considerable development between Dartmouth Street and Massachusetts Avenue. Interestingly, the Commonwealth Avenue Mall has been graded, seeded, and planted with an alley of four trees across to Massachusetts Avenue.

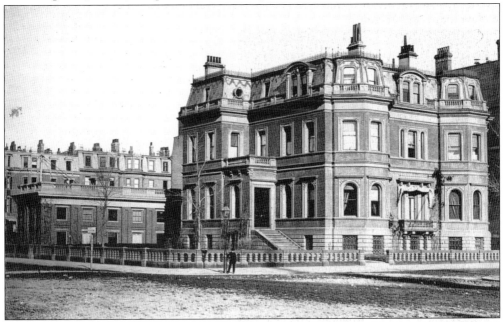

At the corner of Berkeley Street, the duplex house of Thorndike K. Lathrop and Samuel Hooper, on the left, was built in 1861 at 27 and 25 Commonwealth Avenue, respectively. Probably one of the most charming of Back Bay townhouses, it had a brownstone balustrade encircling the property. On the left are townhouses on Marlborough Street. (Courtesy the Boston Public Library Print Department.)

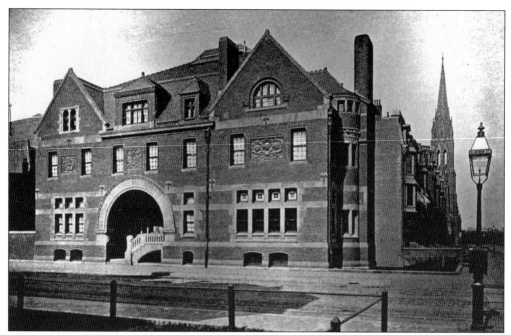

The rectory of Trinity Church was built at the corner of Clarendon and Newbury Streets. Designed by Henry Hobson Richardson, the rectory was built in 1879, and a third story was added later. (Author's collection.)

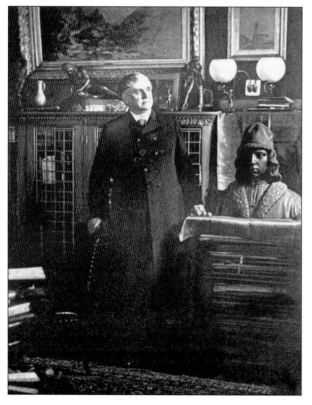

Seen is Rev. Phillips Brooks in his study at the rectory of Trinity Church. (Author's collection.)

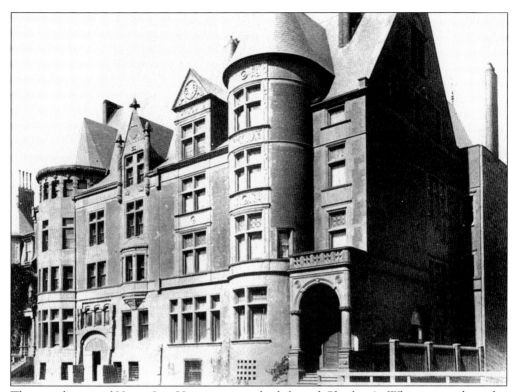

The townhouses of Henry Lee Higginson, on the left, and Charles A. Whittier, on the right, were built in 1881 at 270 and 274 Beacon Street, respectively. Higginson commissioned H.H. Richardson to design his townhouse, and Whittier commissioned McKim, Mead, and White to design his. Later to become the University Club, they were demolished in 1929, and apartment buildings were built on the site.

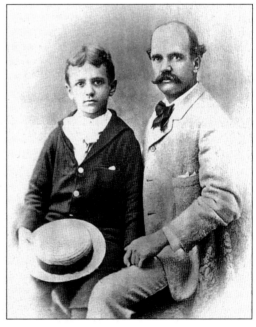

Henry Sturgis Russell (1838–1905), on the right, and his son Howland Shaw Russell lived in the Back Bay but kept an estate in Milton known as the Home Farm, a vast 300-acre horse stud where Sturgis bred Smuggler and Fearnaught, two champion race horses. Russell served as fire commissioner for Boston and was a trustee of the Milton Public Library. (Courtesy the Captain Forbes House Museum.)

73

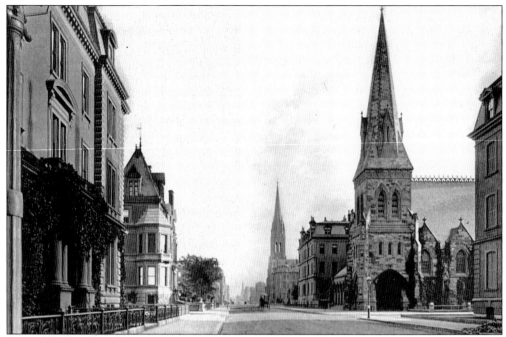

This view looks south on Berkeley Street from Beacon Street. The First Church in Boston and the Central Congregational Church (now Church of the Covenant) are seen on the right. On the left (on opposite corners of Marlborough Street) are the Charles Minot house, designed by Snell and Gregerson and built in 1865, and the John C. Phillips house, designed by Peabody and Stearns and built in 1877. (Author's collection.)

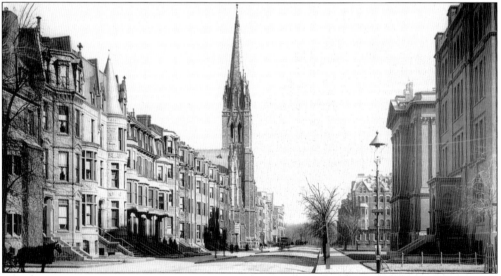

In this easterly view of Newbury Street c. 1870, the spire of the Central Congregational Church (now Church of the Covenant) dominates the streetscape. On the far left are the rectory of the Trinity Church and townhouses that were built between 1869 and 1872. On the right are the rear of the Walker and Rogers Buildings of the Massachusetts Institute of Technology. In the center distance is the Hotel Kempton, built in 1869, now the site of Brooks Brothers. (Courtesy the Boston Public Library Print Department.)

The Perkins townhouse was at 223 Commonwealth Avenue. It was designed by Cabot and Chandler and built in 1883 for George Higginson. A four-story townhouse, it had a rough-hewn granite base with red-brick and brownstone details. (Courtesy the Captain Forbes House Museum.)

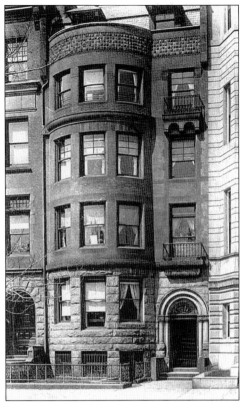

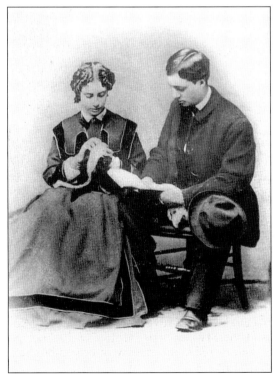

Edith Forbes Perkins and her husband, Charles Elliott Perkins, seen in 1864, purchased a townhouse in the Back Bay in the 1880s, when they stayed in town. They also kept a house on Milton Hill near her family's estate and a vast estate known as the Apple Trees in Burlington, Iowa. Perkins was president of the Burlington Northern Railroad. (Courtesy the Captain Forbes House Museum.)

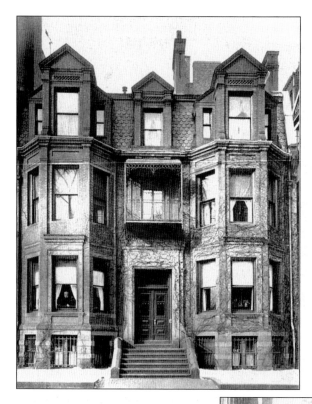

The Forbes townhouse was designed by Robert S. Peabody, a classmate of Forbes at Harvard, in 1879 and built at 107 Commonwealth Avenue for J. Murray and Alice Bowditch Forbes. A center-entrance house with flanking octagonal bays, it was smaller than some of the other townhouses along Commonwealth Avenue. On the first floor on the left is J. Murray Forbes sitting in the window. (Courtesy the Captain Forbes House Museum.).

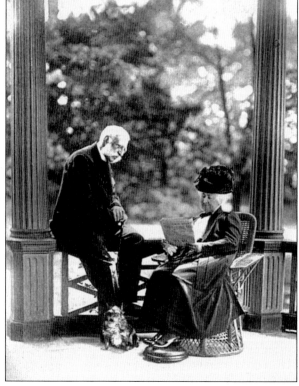

J. Murray Forbes and Alice Bowditch Forbes sit for a photograph celebrating their 50th wedding anniversary on the octagonal porch of the Castle, their spring and fall house on Milton Hill. They kept their townhouse on Commonwealth Avenue for the season but summered in Isleboro, Maine. (Courtesy the Captain Forbes House Museum.)

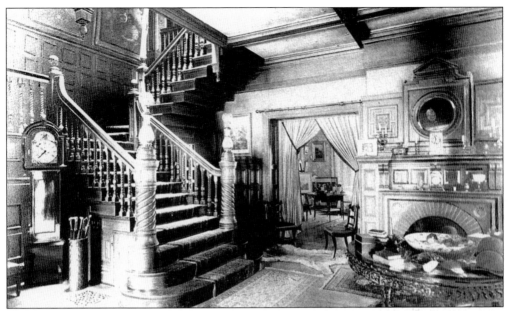

The entrance hall of 107 Commonwealth Avenue had an impressive oak staircase that ascended both sides of the townhouse. Architect Robert S. Peabody created a sitting area, on the right, with an oak mantel, paneled wall, and a brick fireplace. The room was as inviting as it was welcoming in such a grand setting. The drawing room can be see beyond the portieres in the doorway. (Courtesy the Captain Forbes House Museum.)

Mary Bowditch Forbes was the eldest daughter of J. Murray and Alice Bowditch Forbes. A great collector of Lincoln memorabilia, she had a replica of the birthplace of Abraham Lincoln built on the family's estate on Milton Hill. It opened in 1924, and much of her collection was displayed there. She often walked from the Back Bay to Milton Hill, a good six-mile walk. (Courtesy the Captain Forbes House Museum.)

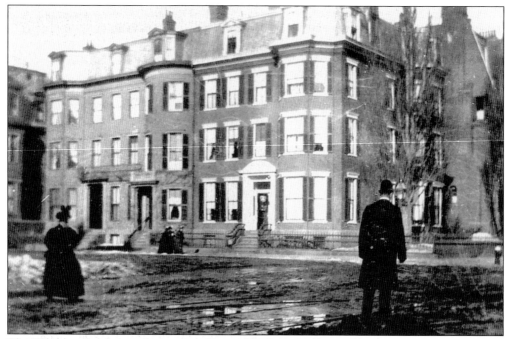

The Whitney family townhouse was designed by D.D. Kelley and built in 1880 for speculator S.T. Ames at 232 Marlborough Street. Marlborough Street, named for the Colonial street in downtown Boston, was a cross street between Commonwealth Avenue and Beacon Street. It was more domestic in scale than the Commonwealth Avenue Mall, where the grander houses were located. (Courtesy the Carr family.)

Joseph Cutler Whitney (1856–1911) was a trustee of estates and a principal in the wool business of Drake and Company. The son of Henry Austin Whitney, the president of the Boston and Providence Railroad, Whitney kept a Back Bay townhouse and a large estate in Milton that included the Tucker house, the oldest house in that town, known as the Centuries. (Courtesy the Milton Public Library.)

The Cushing family townhouse was designed by Snell and Gregerson and built in 1871 for Thomas F. Cushing at 165 Marlborough Street. The entrance is an imposing porch of four Doric columns supporting a bracketed lintel. Above are a modified Palladian window and a cast-iron balcony.

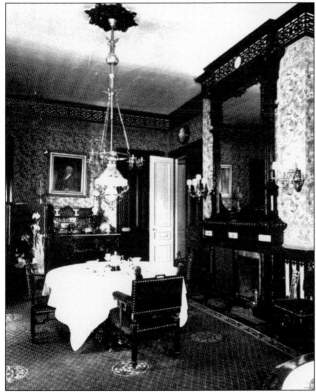

The dining room of the Cushing house had ebony woodwork that was imported from the Orient, as well as ebony furniture. The walls were papered in a yellow-green wallpaper, also imported from the Orient, which shows the owner's strong connections to the China trade.

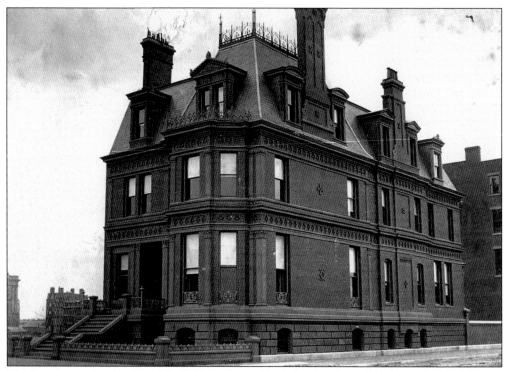

This townhouse was designed by C.R. Kirby and built by developer J.D. Bates in 1874. It was located at the corner of Commonwealth Avenue and Dartmouth Street. (Courtesy the Boston Public Library Print Department.)

In this view, a woman has stopped in a horse-drawn open carriage in front of a townhouse on Commonwealth Avenue. (Courtesy the Boston Public Library Print Department.)

The homes at 268 Newbury Street, on the left, and 270 Newbury Street were designed by G. Wilton Lewis and built in 1882 for developer Silas Merrill. The developer's houses between 254 and 280 Newbury Street were all designed in the Queen Anne style by Lewis and built at the same time. (Courtesy the Boston Public Library Print Department.)

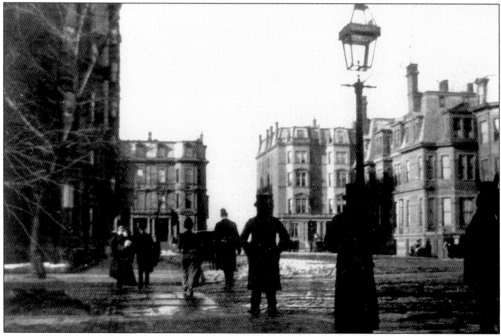

In this 1895 view of Dartmouth Street that looks toward Beacon Street, the result of three decades of building is seen. The well-designed townhouses by prominent architects are uniform in height, share building materials, and are set back from the sidewalk, creating a feeling of cohesion in the neighborhood. (Courtesy the Carr family.)

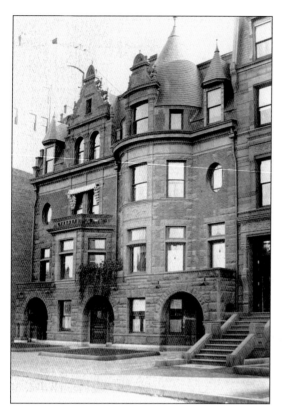

The homes at 176 and 178 Commonwealth Avenue were planned with a unified design by Charles Atwood and built in 1883 for the Wesselhoeft and Bell families. The continuous entrance porch shared by both townhouses was punctuated by three arches and extended to the sidewalk, creating an interesting first floor.

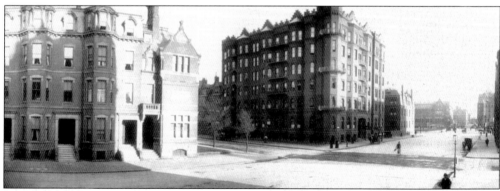

The Hotel Victoria dominates the center of this photograph from 1900. It was designed by J.L. Faxon and built in 1886 at the corner of Dartmouth and Newbury Streets. On the left are 283, 281, 277 Dartmouth Street, the left having been built by James Standish and the right by J.P. Putnam. In the distance are the Museum of Fine Arts and the S.S. Pierce Company building at Copley Square. (Author's collection.)

The home at 127 Newbury Street was designed by F.H. Moore in 1873, along with 125 Newbury Street, on the left, as speculative property. (Author's collection.)

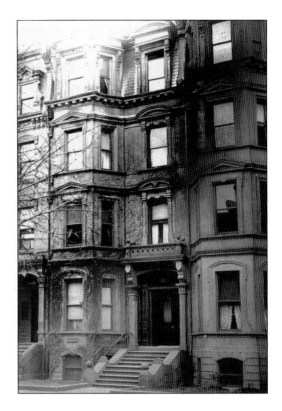

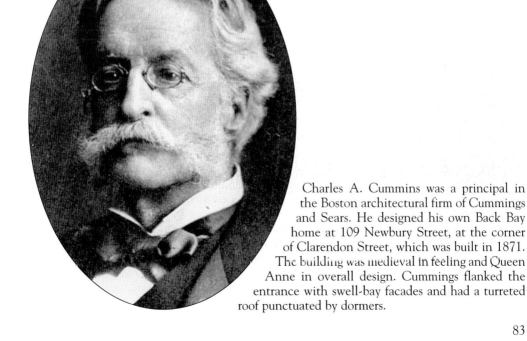

Charles A. Cummins was a principal in the Boston architectural firm of Cummings and Sears. He designed his own Back Bay home at 109 Newbury Street, at the corner of Clarendon Street, which was built in 1871. The building was medieval in feeling and Queen Anne in overall design. Cummings flanked the entrance with swell-bay facades and had a turreted roof punctuated by dormers.

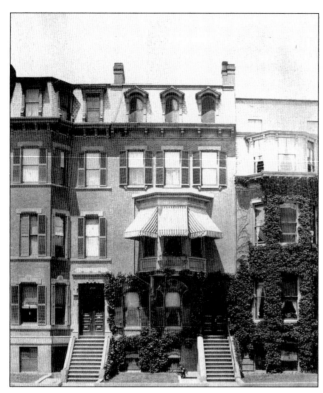

The home of Dr. Oliver Wendell Holmes was built in 1870 near Exeter Street and lived in by three generations of the family. A simple three-story red-brick house, it was distinguished by a three-bay oriel window that was adorned with striped awnings. The house was demolished in 1950, and an apartment building, designed by H.L. Feer, was built on its site.

Dr. Oliver Wendell Holmes was one of Boston's great noblemen, a poet, a philosopher, a scholar, and a physician. A professor at Harvard College, Holmes is probably best known for his book *Autocrat of the Breakfast Table*.

The George A. Nickerson house was designed by McKim, Mead, and White and was built in 1895 at 303 Commonwealth Avenue. After his death in 1901, his widow, Ellen Touzelin Nickerson, was married abroad to Horace L. A. Hood and eventually was granted the courtesy title of Lady Hood of Whitley.

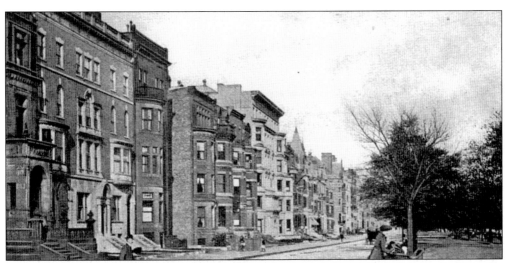

In this c. 1900 view looking down Commonwealth Avenue from Massachusetts Avenue, the urbane and sophisticated streetscape is beyond compare. The tall building in the center is the Hotel Lafayette, designed by McKay and Dunham and built in 1895 at 333 Commonwealth Avenue as a residential apartment building. The building at 347 Commonwealth Avenue, on the left, was designed by Allen and Kenway and built in 1888 for M.B. Mason.

Robert Dawson Evans (1843–1909) was a native of Canada and was the principal of the United States Rubber Company. He and his wife, Maria Antoinette Hunt Evans, were art collectors and eventually donated not just the bulk of their collection to the Museum of Fine Arts, but provided the funds for the museum's Evans Memorial Wing, which was designed by Guy Lowell and built in 1915 overlooking the Fenway.

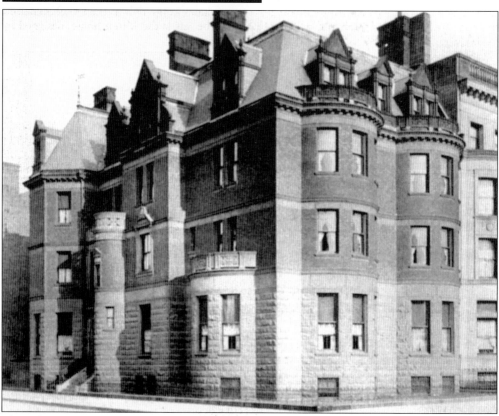

The Thayer-Evans house was designed by Sturgis and Brigham and built in 1886 at 17 Gloucester Street, at the corner of Commonwealth Avenue.

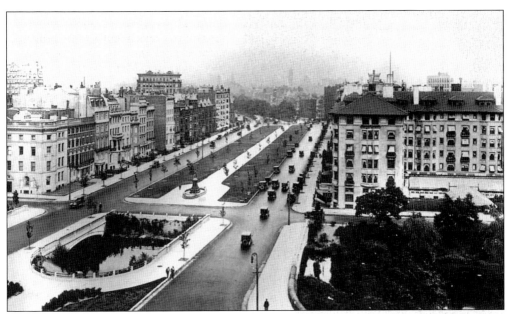

Seen in a view looking east on Commonwealth Avenue from Charlesgate West, the former area of the Muddy River has been transformed by Frederick Law Olmsted and his successors into a green space bisected by the Commonwealth Avenue Mall. On the right is the Hotel Somerset, designed by Arthur Bowditch and built in 1897. On the left is the Minot house, designed by Peabody and Stearns and built in 1891 at 24 Charlesgate East.

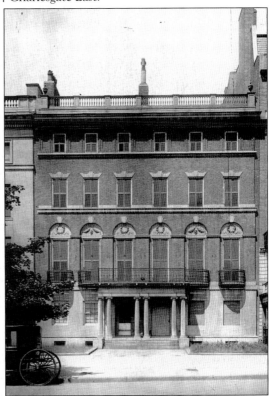

Built in 1890, the Richard Olney house, on the left, and the F.D. Amory house, on the right, were in a duplex townhouse designed by McKim, Mead, and White at 413–415 Commonwealth Avenue. These townhouses emulated the earlier Neoclassical houses of Federal Boston, but on a grander scale.

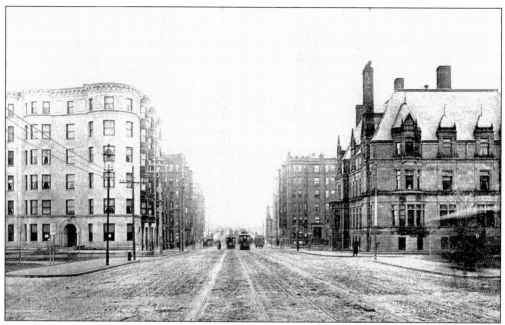

Massachusetts Avenue extended from the South End through the Back Bay and continued on toward Cambridge, which was serviced by streetcars. Seen here at Commonwealth Avenue is the 1882 Oliver Ames house, on the right, a chateauesque mansion designed by Carl Fehmer. On the left is an apartment building designed by McKay and Dunham and built in 1892.

Oliver Ames was a successful manufacturer of shovels in Easton, where he also provided the funds to erect handsome public buildings by H.H. Richardson. Ames served as governor of Massachusetts for three terms where, it was said, he gave the people a business administration that has seldom been equaled and never surpassed.

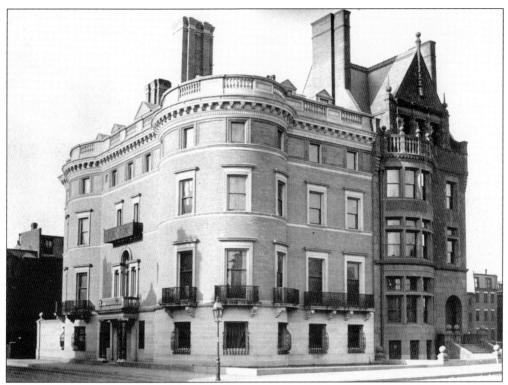

The John Andrew house was designed by McKim, Mead, and White and built in 1884 at 32 Hereford Street, at the corner of Commonwealth Avenue. On the third floor above the Palladian window is an iron balcony brought from the Tuileries in Paris, France. On the right is the Thayer house, designed by Peabody and Stearns and built in 1884.

John Forrester Andrew (1850–1819) attended Harvard College and Harvard Law School, after which he served in the state legislature and the state senate before serving as a U.S. congressman. The son of the great "War Governor" of the Commonwealth John Albion Andrew, John Forrester was a benevolent man who was active in charity work and a friend of laborers and Civil War veterans. (Author's collection.)

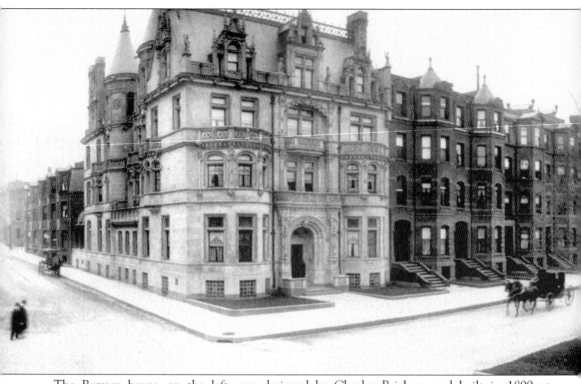

The Burrage house, on the left, was designed by Charles Brigham and built in 1899 at 314 Commonwealth Avenue at the corner of Hereford Street. A rare example of a French chateauesque mansion in Boston, where the architectural styles for Back Bay townhouses were more restrained, it is a massive house with turrets, dormers, and architectural details that

Charles Brigham, a principal of Sturgis and Brigham and later Brigham, Coveney, and Bisbee, was to create one of the Back Bay's most elaborate mansions for the Burrage family. Using architectural elements from various chateaux of the Loire Valley in France, he created one of the most inspiring designs of the turn of the century. A dearth of detail, carvings, gables, towers, and turrets made his design unique in Boston simply for the vast cost involved.

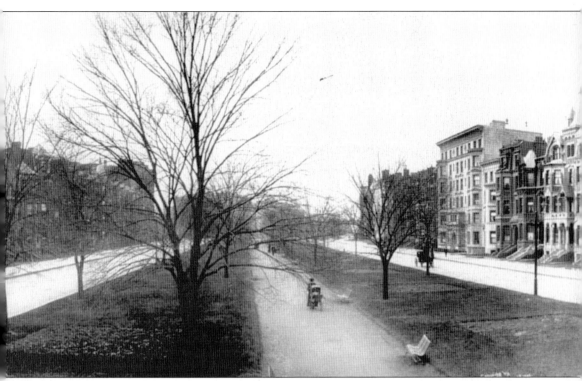

make it unique. To the right is a row of red-brick houses built in 1881 and 1882 and designed by S.D. Kelley and Bradlee and Winslow. The Commonwealth Avenue Mall is a wide swath of greenery, and on the north side of Commonwealth Avenue can be seen a tall building, the Hotel Lafayette, designed by McKay and Dunham and built in 1895. (Author's collection.)

Albert Cameron Burrage served as president of the Massachusetts Horticultural Society and was a prominent attorney in Boston. He served as a member of the Boston Common Council and was a member of the Boston Transit Commission.

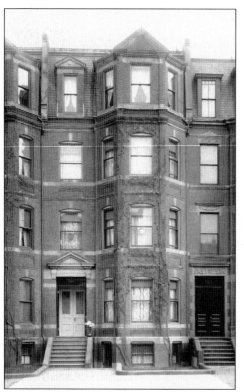

The building at 340 Commonwealth Avenue was designed by Bradlee and Winslow and built in 1882 for the real-estate developer George Wheatland. This townhouse and its mate on the left were typical of the red-brick Queen Anne–style houses built near Massachusetts Avenue. The home at 342 Commonwealth Avenue, on the right, was designed by O.F. Smith and built in 1883. (Courtesy the Society for the Preservation of New England Antiquities.)

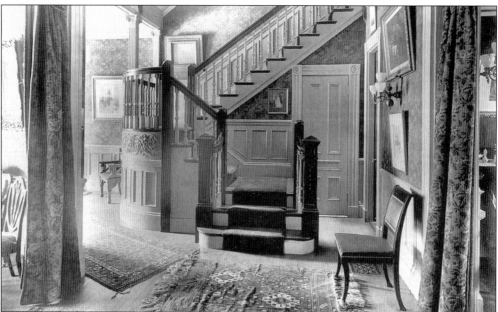

The entrance hall of 340 Commonwealth Avenue had a staircase that created a bowed balcony on the left that overlooked the hall and a short landing at the base of the stairs. Less grand than some of the larger Back Bay townhouses, it was well furnished with fashionable pieces of the early 20th century and a good painting and print collection. (Courtesy the Society for the Preservation of New England Antiquities.)

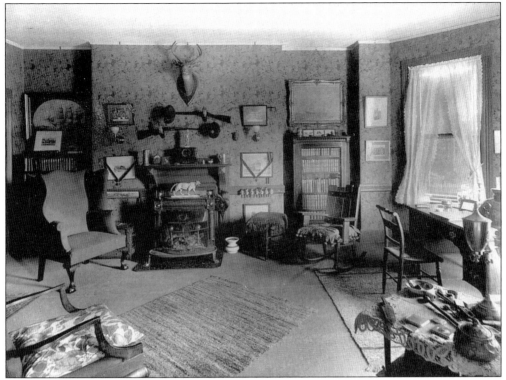

Unlike the formal reception room, the study at 340 Commonwealth Avenue was comfortably furnished with big wingchairs, well-stocked bookcases, a deer head above the fireplace, and paintings of the family clipper ships that traveled in the mid-19th century to China. (Courtesy the Society for the Preservation of New England Antiquities.)

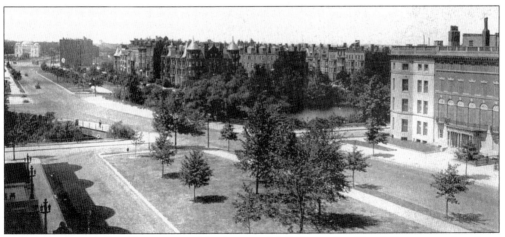

Looking west on the Commonwealth Avenue Mall from the Hotel Somerset, the three townhouses on the right are the Minot house, designed by Peabody and Stearns, and the duplex Olney and Amory houses, designed by McKim, Mead, and White. The area just past Charlesgate West had been built between 1891 and 1895, with the houses closest (461–471 Commonwealth Avenue) designed by S.D. Kelley and built in 1891.

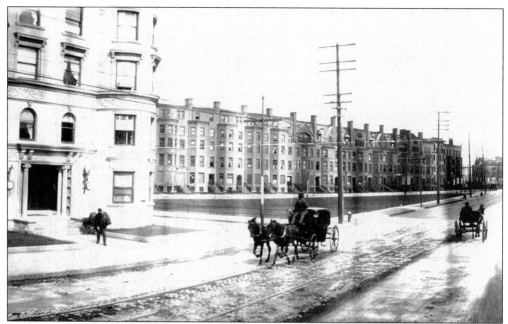

Beacon Street intersects Commonwealth Avenue at Governor's Square, now known as Kenmore Square. Seen here in 1900, the Hotel Belvoir, a residential apartment building, is on the far left, and a row of townhouses designed by S.D. Kelley along Baystate Road can be seen in the distance.

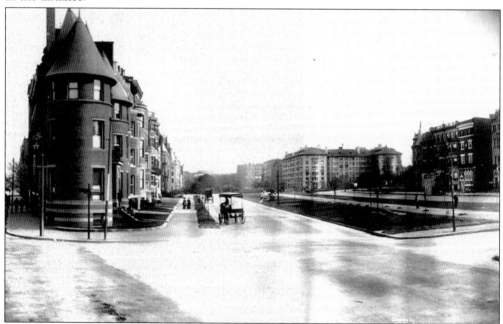

This view, looking east from Governor's Square, shows that Commonwealth Avenue had been extended to the Back Bay Fens, an area created by Frederick Law Olmsted from the former Muddy River. On the left is the Rollins house, a red-brick turreted townhouse designed by Walker and Kimball and built in 1895. Today, it is the Waterman Funeral Home. In the distance is the Hotel Somerset, designed by Arthur Bowditch and built in 1897.

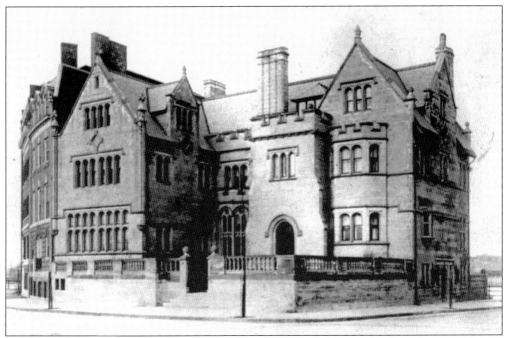

The Lindsey house was designed by Chapman and Fraser and built in 1905 at 225 Baystate Road. A large Medieval Tudor–style townhouse, it was referred to as the Castle. Sold by the family in 1927, it is today part of the campus of Boston University and is used as a social center.

William Lindsey (1858–1921) derived his wealth from an ammunition belt he invented that was widely used throughout the world in the late 19th century. A benevolent man, after his daughter's death on the *Lusitania* in 1915, he provided the funds for the Leslie Lindsey Chapel at Emmanuel Church, designed by Allen and Cullen, to be built in 1920 in her memory.

Charles Goddard Weld (1857–1911) was a noted physician but derived his considerable wealth from the family's involvement in the China trade. He was an avid collector of Orientalia, including paintings, swords, sword guards, and objects in metal, lacquer, and ivory. Most of it was bequeathed to the Museum of Fine Arts, of which he had served as a trustee.

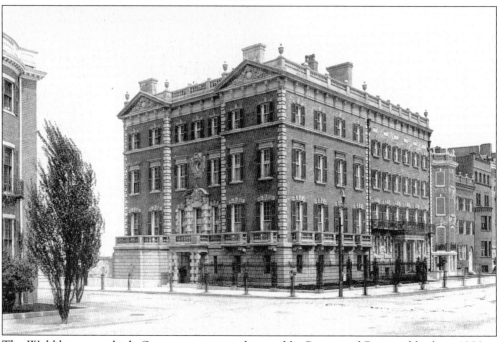

The Weld house is a high-Georgian mansion designed by Peters and Rice and built in 1900 at 149 Bay State Road. On the right are the Gorham Peters house and the William York Peters house, both designed by Peters and Rice and built in 1900. On the left is the Pitman house, designed by Wheelwright and Haven and built in 1893. Today, the Weld house is owned by Boston University and is used as administrative offices. (Author's collection.)

Six

COPLEY SQUARE

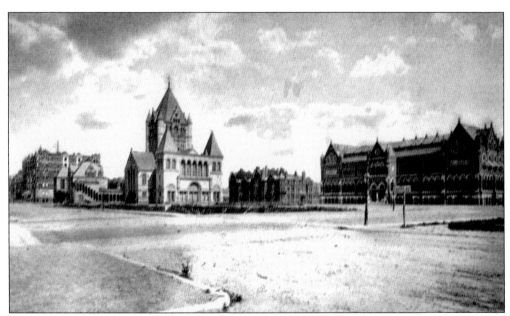

The center of the Back Bay is Copley Square, an area bounded by Boylston Street, Clarendon Street, Dartmouth Street, and St. James Avenue. Seen here in 1885 from the corner of Dartmouth and Boylston Streets, the impressive Trinity Church had been built facing the open square, with the Museum of Fine Arts on the right. Trinity, the masterpiece of H.H. Richardson, dominates its space and was consecrated in 1877.

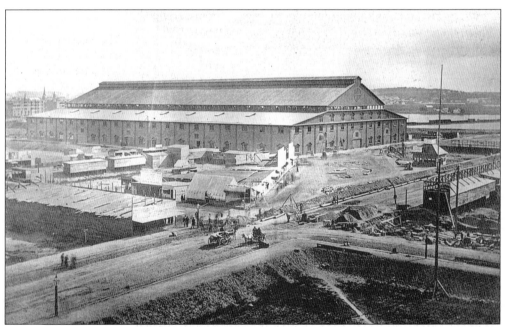

Originally known as Art Square, the area was renamed Copley Square in 1883 in honor of the fashionable portrait painter John Singleton Copley (1737–1718). Once a resident of Boston living on Beacon Street on Beacon Hill (roughly the site of the Somerset Club), Copley left America during the Revolution and lived the remainder of his life in London.

The area of Dartmouth and Boylston Streets had been infilled in the 1860s and was used initially for the massive Peace Jubilee coliseum, which was an enormous building designed by William Gibbon Preston that had the largest interior seating capacity in New England in the 19th century. Beginning in 1869, a celebration of peace through music following the Civil War was held there. Today, the area is part of Copley Place.

Lowell Mason was the promoter of the great Peace Jubilee at the coliseum. A well-respected and eminent musician, Mason oversaw thousands of singers and musicians who came from all parts of the United States as well as from England, Ireland, France, and Germany to participate. Mason and those involved strove to reunite citizens through music.

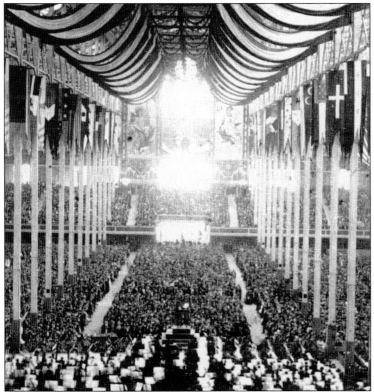

The interior of the coliseum was 130 feet long and had streamers of red, white, and blue adding color to the roof with flag-bedecked columns that were hung with banners. An organ built by J.H. Willcox and Company accompanied the grand musical pieces directed by Patrick Sarsfield Gilmore, some of which had hundreds of participants. The Anvil Chorus had the audience clapping their hands, stomping their feet, and pounding their canes on the floor.

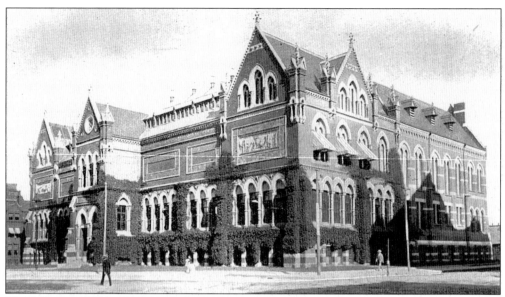

The Museum of Fine Arts was built on St. James Avenue at the corner of Dartmouth Street facing Art Square, the open area in the foreground. Designed by the noted Boston architectural firm of Sturgis and Brigham, the museum was an impressive and bold Italian Gothic design in red brick with elaborate terra-cotta designs. Founded in 1870, the museum was to become a major part of the Boston Brahmin's interpretation of European culture and influence in Boston. It opened on July 4, 1876.

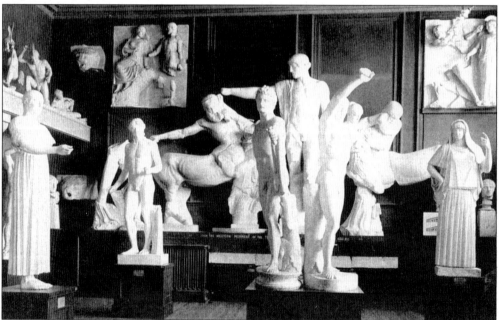

One of the galleries in the third-floor Greek galleries had one of the most complete collections of plaster casts in the United States. Many of these casts had belonged to the Boston Athenaeum and were loaned to the museum and included bas-reliefs from the frieze of the Parthenon and from the Temple of the Wingless Victory, as well as such popular pieces such as the torso of Victory, the Venus de Milo, and the Apollo Belvedere.

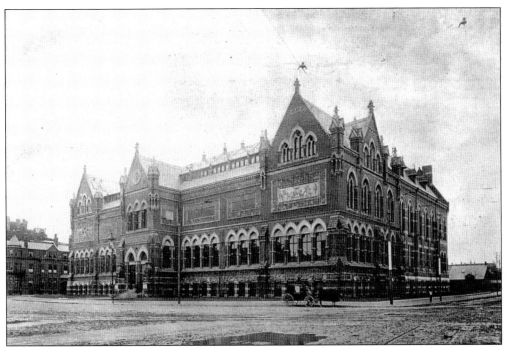

The facade of the Museum of Fine Arts was eventually doubled in size in 1890 (the right side was the original) and had white-marble steps and polished-granite columns with terra-cotta capitals. On either end of the museum were large rectangular allegorical compositions *The Genius of Art* and *Art and Industry,* which were executed in terra cotta. Closed in 1909, the museum moved to the Fenway, and the Copley Plaza Hotel was built on its site.

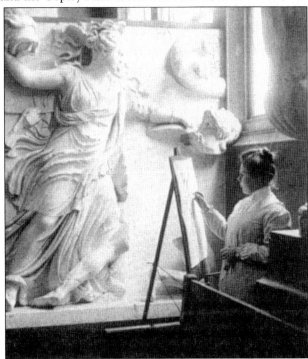

The museum was the first true example in Boston of fostering art appreciation, and many Bostonians donated and loaned pieces of art that were displayed in the galleries. In this view, a woman sketches the dynamic pose of a plaster cast.

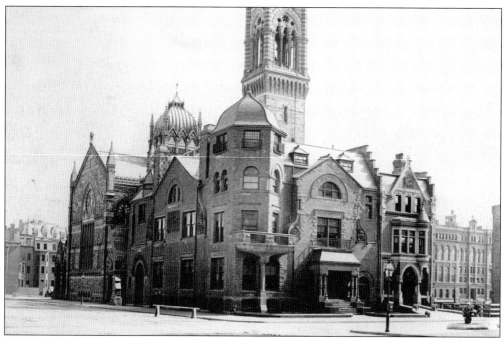

The Boston Art Club, founded in 1854 to advance the knowledge and love of art, was designed by William Ralph Emerson and built in 1881 at the corner of Newbury and Dartmouth Streets. An impressive Queen Anne design built of red brick, terra cotta, and brownstone, it was adjacent to the New Old South Church. Emerson, a resident of Milton, was best known for his country houses and is known as the father of Shingle-style architecture. The Bryant and Stratton school was later located here.

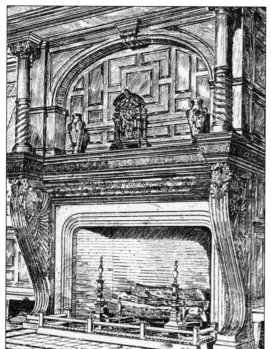

A sketch of the mantel in the reading room of the Boston Art Club, designed by William Ralph Emerson, appeared in the *American Architect and Building News*. Massive in its design, the mantel was of heavily carved oak with collonettes flanking an arched niche above the tiled fireplace. Emerson's use of traditional English design details made the interior as welcoming as it was comfortable.

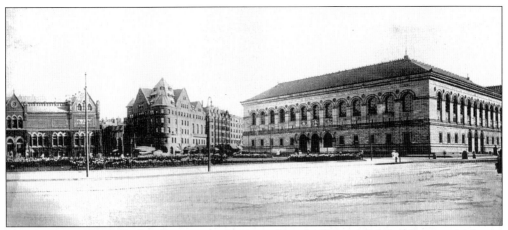

The western side of Copley Square was dominated by the Boston Public Library, which was designed by McKim, Mead, and White to emulate an Italian Renaissance palazzo. On the far left is a corner of the Museum of Fine Arts, and in the center is the S.S. Pierce building.

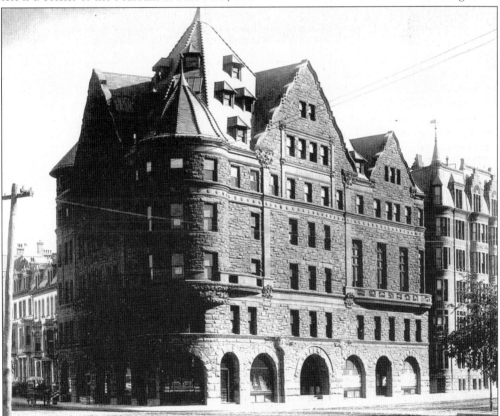

The S.S. Pierce Company built its eight-story Back Bay store at the corner of Dartmouth Street and Huntington Avenue. Designed by S. Edwin Tobey, it was a massive castlelike structure of rough-hewn stone, brownstone, and terra cotta and had Romanesque arches on the first floor for entrances as well as display windows. Wallace Lincoln Pierce was the son of the founder and a resident of 350 Beacon Street in the Back Bay. He saw the opening of this branch as a decisive one for his business.

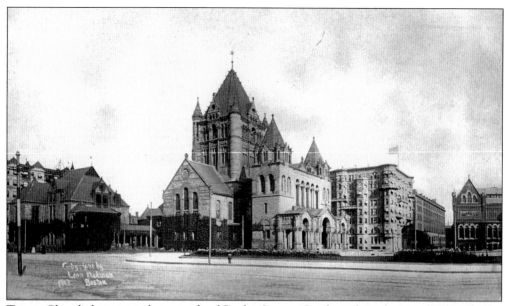

Trinity Church dominates the east side of Copley Square. On the right is the Hotel Westminster, designed by Henry E. Cregier with elaborate terra-cotta decorative details and caryatids sculpted by Max Bachman. On the right is a corner of the Museum of Fine Arts.

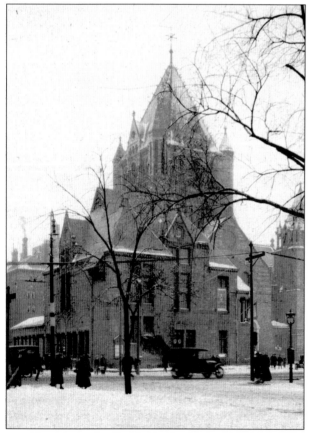

The rear of Trinity Church, seen from near the corner of Claredon and Boylston Streets, has the chapel in the foreground. Impressive from every side, Trinity Church is truly Gambrill and Richardson's masterpiece and creates a focal point in Copley Square. (Author's collection.)

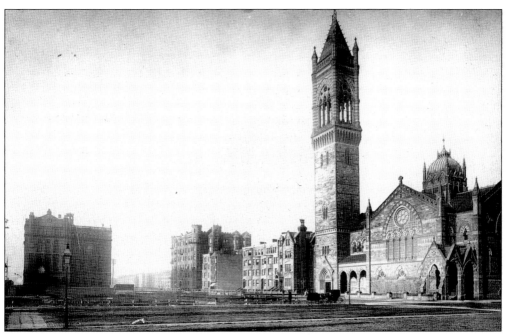

Copley Square, seen in 1880, was dominated by New Old South Church, which had relocated to the corner of Boylston and Dartmouth Streets from the downtown section of Boston. Designed by Cummings and Sears and completed in 1875, the church was a Northern Italian Gothic design with a soaring bell tower. On the left is the Harvard Medical School, designed by Ware and Van Brundt in 1881 and later used as the Boston University College of Liberal Arts.

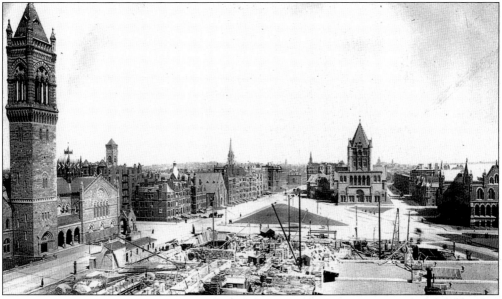

In this view, looking east from the roof of the Boston University School of Medicine, the foundation for the Boston Public Library is being laid. Trinity Church commands the center of Copley Square and is flanked by the New Old South Church on the left and the Museum of Fine Arts on the right. Boylston Street, which had been laid out in the 1860s, is lined with brick and brownstone houses, as seen between Dartmouth and Clarendon Streets.

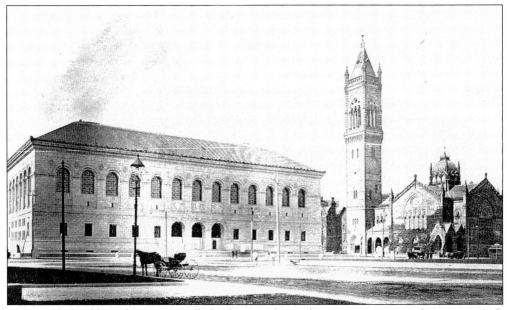

The Boston Public Library was called "the People's Palace" upon its completion in 1895. Founded in 1854, the library was originally located on Boylston Street opposite the Boston Common, but land was purchased on Dartmouth Street in the new Back Bay, and McKim, Mead, and White were commissioned to design the library building. It is thought to be based on the Bibliotheque Nationale in Paris. On the right is the New Old South Church.

Charles Follen McKim (1847–1909) was the principal in the architectural firm of McKim, Mead, and White. A graduate of Harvard and the Ecole des Beaux Arts in Paris, he was initially associated with Gambrill and Richardson, but he subsequently founded his well-respected architectural firm in 1880 and became preeminent for impressive, well-designed buildings.

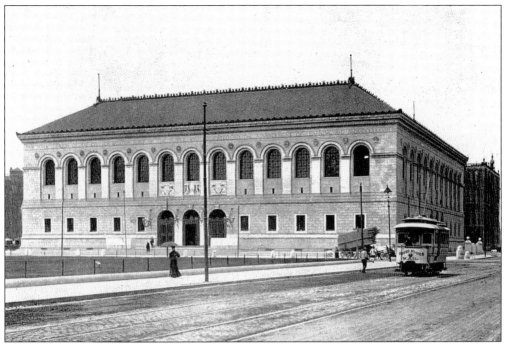

With its repetitive arches, the facade of the Boston Public Library exemplifies the well-ordered and classically correct architectural style of McKim. Said to demonstrate "a sense of civic responsibility of the highest order, responsive to the buildings and environment around it," the Boston Public Library was to be called one of the finest Renaissance designs in the United States.

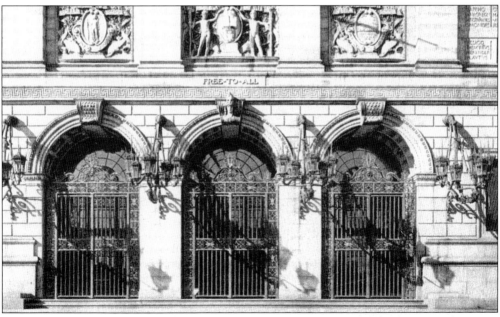

The tri-arched entrance to the Boston Public Library created a sense of grandeur with the center arch being surmounted by a bust of Athena Nike with the motto "Free to All" directly above.

Art, a seated statue sculpted by Bela Pratt, was placed on a base in front of the Boston Public Library facing Copley Square in 1912. Its mate is *Science*, on the other side of the library entrance. (Author's collection.)

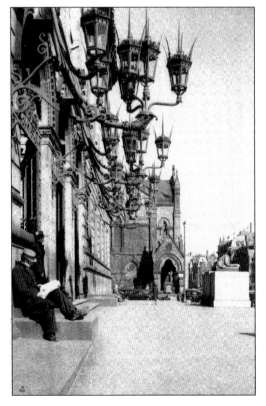

The lanterns that adorn the facade of the Boston Public Library provide light to dispel the darkness and also act as architectural elements that enhance the overall design that McKim, Mead, and White tried to convey. Here, a patron sits just outside the entrance on a raised patio overlooking Dartmouth Street. (Author's collection.)

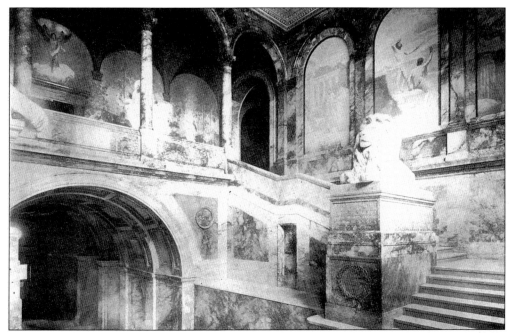

The grand staircase was embellished with seated lions (sculpted by Louis Saint Gaudens) that were memorials to the Civil War dead. The staircase has rich Sienna marble in various colors and murals by Puvis de Chauvannes. (Author's collection.)

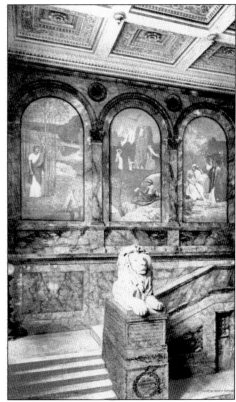

A massive lion surmounts a pier on the grand staircase at the Boston Public Library. With a backdrop of murals by Puvis de Chavannes in arched panels and a heavily coffered ceiling, the grand staircase was as imposing as it was elegant. (Author's collection.)

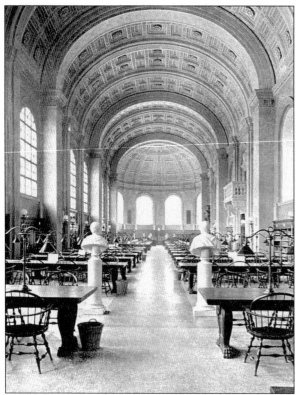

Bates Hall was named for Joshua Bates, the American representative to Baring Brothers in London whose generosity to the Boston Public Library is legendary. Bates Hall is 218 feet in length and has a lofty coffered barrel vaulted ceiling with pilasters supporting the arches. Massive in size and scale, it is the main reading room at the library.

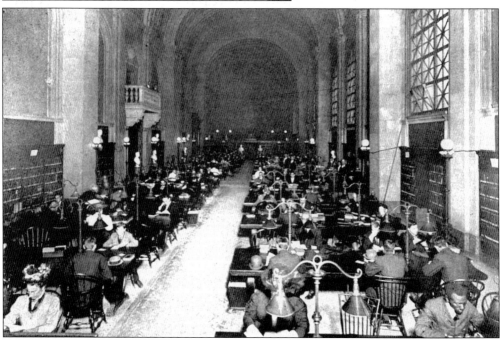

Seen in 1912, Bates Hall was rarely without patrons after the library opened in 1895. Patrons sat at the long reading tables that were illuminated by large reading lamps. Free to all, as it was engraved on the facade, the Boston Public Library was patronized by people from all walks of life.

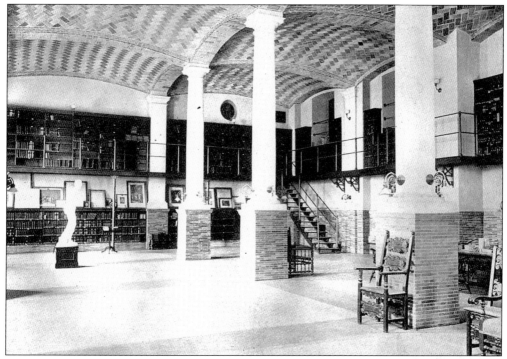

The magazine room at the library was a large room with Doric columns supporting the brick coved ceiling. Local, national, and international magazines were available to library patrons, who could sit and read in one of the elaborate carved chairs, seen on the right, or admire pieces of art throughout the museum.

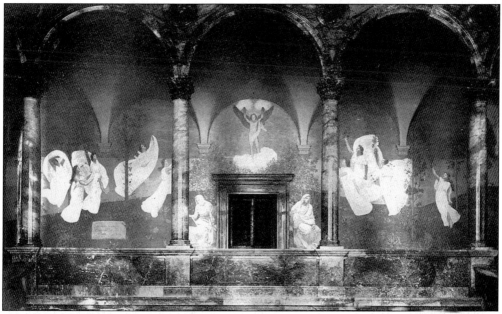

The Muses Welcoming the Genius of Enlightenment was painted by Puvis de Chavannes at the Boston Public Library in the second-floor hall of the grand staircase. With a rich frame of Sienna marble, it is an important work of public art.

John Singer Sargent (1856–1925) was preeminent among artists even during his lifetime. An American expatriate living abroad, Sargent was commissioned by the Boston Public Library in 1890 to paint frescos in Sargent Hall. Working closely with Charles McKim, he was to create a dramatic and impressive fresco of rich tones that was an integral part of the overall architectural design of the space.

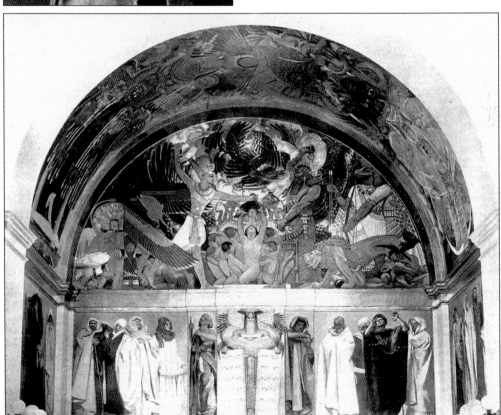

The Dawn of Christianity was painted by John Singer Sargent on the third floor of the Boston Public Library.

112

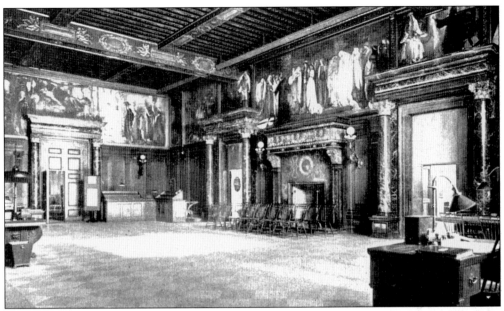

The delivery room was a monumental room where books were brought to library patrons in the early years after the library was opened in 1895. With a large fireplace and doorways flanked by stone columns, the room was to be embellished with the murals by Edwin Austin Abbey.

Edwin Austin Abbey (1852–1911) was a noted illustrator, etcher, and painter whose work included the Holy Grail murals at the Boston Public Library. Among his friends were the painters Sargent, Whistler, and Alma-Tadema, who created a new sense of artistic achievement in the early 20th century.

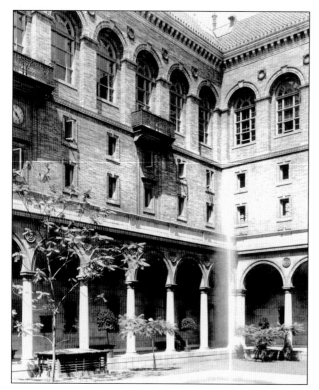

The courtyard of the Boston Public Library has yellow brick-faced walls with a colonnade of Doric columns supporting a bold cornice. The upper floor has large windows set within recessed niches, all of which overlook the center fountain.

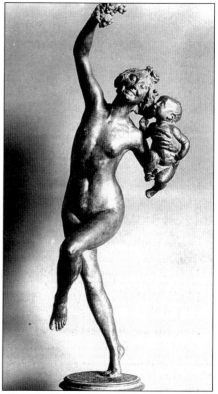

Bacchante and Infant Faun, a gift to the library from Charles F. McKim, was a bronze sculpture designed by Frederick MacMonnies (1865–1937) to be the centerpiece of the fountain in the courtyard. The nude figure of a woman holding a hand of grapes above her head as she lightly dances with a child in her arm was too much for Back Bay dowagers, whose protests on opening day and subsequent ones created such a furor that it was removed. A copy was later placed in the courtyard of the present Museum of Fine Arts.

Seven

TRANSPORTATION

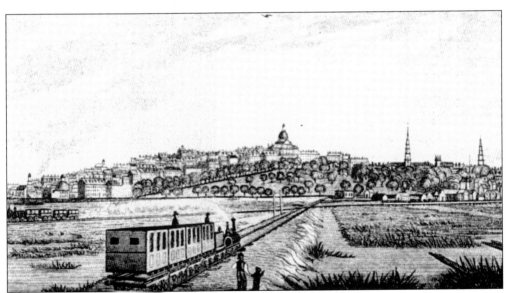

A train of the Boston and Providence Railroad heads toward the depot at Park Square in this 1840s print. On the far left is a Boston and Worcester Railroad train. The dome of the Massachusetts State House dominates the print, done by John Warner Barber, but on either side of the embankment supporting the railway line are the marshes of the Back Bay.

In this view, which looks from the corner of the Boston Common at the corner of Boylston and Charles Streets, with the famous apple lady and a customer in the foreground, the depot of the Boston and Providence Railroad can be seen in the distance. This area, known as Park Square, was dominated by the depot and numerous passengers who used the railroad line on a daily basis.

The depot of the Boston and Providence Railroad was replaced with an impressive high-style Victorian depot with a four-sided tower that could be seen from all directions. The line had been chartered in 1844, and this was the third depot on the site, now the site of the Park Square Building and the Park Plaza Hotel. In the foreground is the *Emancipation Group*, sculpted by Thomas Ball and presented to the city of Boston in 1879 by Moses Kimball, proprietor of the Boston Museum.

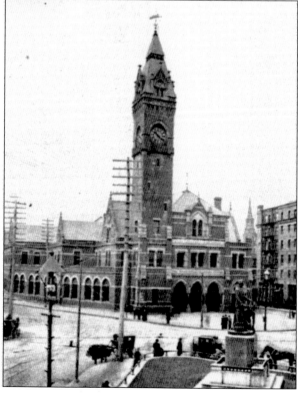

116

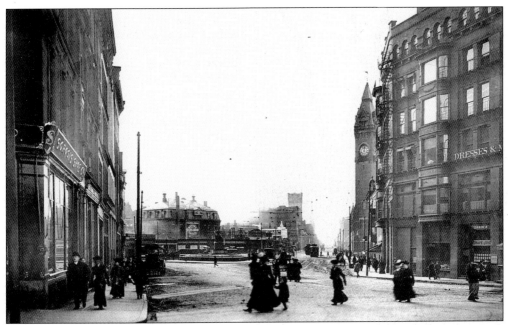

Park Square, seen *c.* 1900 from Boylston Street, was a bustling area of the Back Bay, with numerous stores, office buildings, and commercial concerns located around the square. In the center distance is the crenelated tower of the First Corps of Cadet armory, designed by William Gibbons Preston and built in 1897. To its right is the Boston and Providence Railroad depot. (Courtesy the Boston Public Library Print Department.)

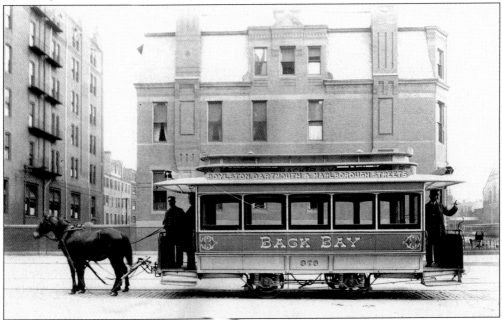

A horsecar stops at the corner of Marlborough and Dartmouth Streets on December 24, 1900, the last day of horsecar service in Boston. Horsecar 373 provided passenger transport along Boylston, Dartmouth, and Marlborough Streets, but after the horsecars were done away with, this line was not replaced by electrified streetcars. (Courtesy Frank Cheney.)

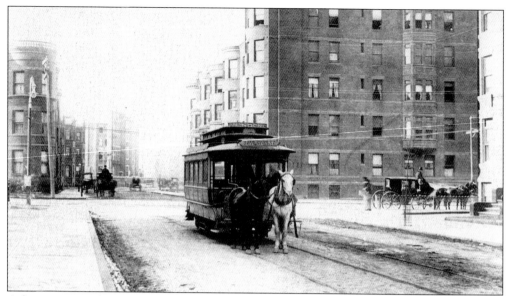

A horsecar travels on Marlborough Street, with Massachusetts Avenue in the distance, on the last day of service, December 24, 1900. This horsecar not only served Marlborough and Boylston Streets but also stopped at the Hotel Vendome, as noted on the front of the car. (Courtesy Frank Cheney.)

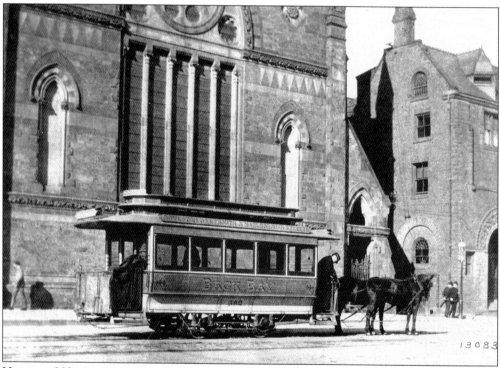

Horsecar 382 pauses in 1900 on Dartmouth Street in front of the New Old South Church, designed by Cummings and Sears and built in 1874 at the corner of Boylston Street. On the right is the Boston Art Club building, designed by William Ralph Emerson and built in 1881 at the corner of Newbury Street. (Courtesy Frank Cheney.)

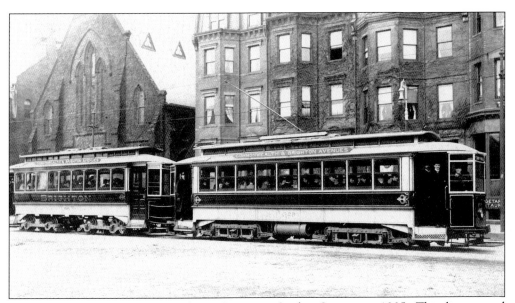

A two-car train is seen on Boylston Street at Copley Square in 1905. This line served Commonwealth and Brighton Avenues, connecting the city with Brighton, a town annexed to Boston in 1874. The car on the left was an old horsecar that was remodeled to serve with a new electrified streetcar on the right. On the left is the Second Church, designed by Nathaniel J. Bradlee and built in 1873, later demolished in 1915. The brick row houses on the right were built in 1877 and 1878.

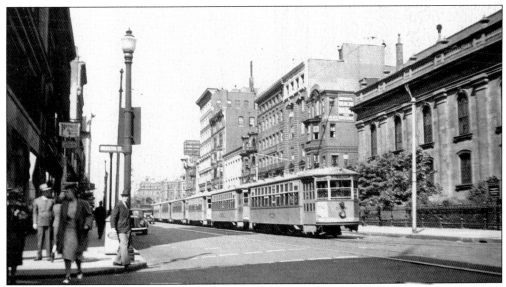

A streetcar travels along Boylston Street, approaching Arlington Street. On the right is the side facade of the Arlington Street Church, designed by Arthur Gilman and built in 1860 at the corner of Arlington and Boylston Streets. (Courtesy Frank Cheney.)

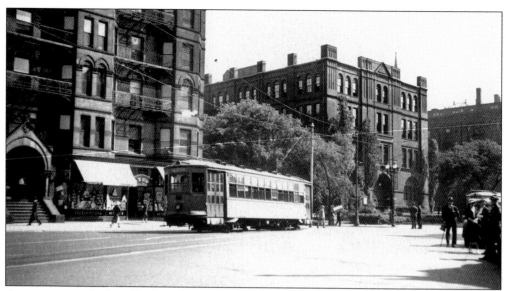

A streetcar travels along Boylston Street and can be seen passing Dartmouth Street. On the right is the Walker Building of the Massachusetts Institute of Technology, designed by Carl Fehmer and built in 1883. On the left are the Hotel Bristol, designed by L. Newcomb and built in 1879, and the Hotel Cluny, designed by J.P. Putnam and built in 1876. (Courtesy Frank Cheney.)

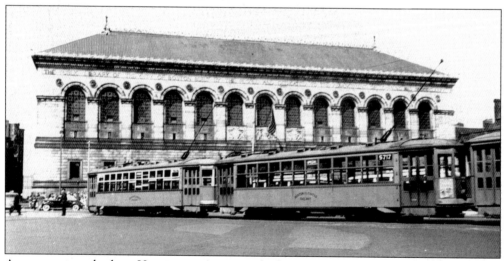

A streetcar travels along Huntington Avenue, which once crossed Copley Square to intersect Boylston Street, in front of the Boston Public Library. Designed by the noted architectural firm of McKim, Mead, and White and begun in 1887, the library opened as "the People's Palace," as it was often called, in 1895. (Courtesy Frank Cheney.)

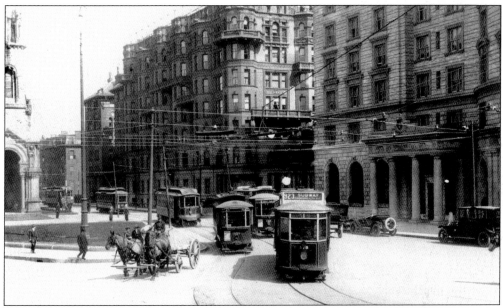

A group of streetcars can be seen on St. James Avenue approaching Copley Square in 1914, as they were detoured due to the construction of the Boylston Street subway between Copley Square and Arlington Street. On the right is the Copley Plaza Hotel, designed by Henry Hardenburg and built in 1911 on the site of the Museum of Fine Arts. In the center is the Hotel Westminster, now the site of the John Hancock tower by I.M. Pei. (Courtesy Frank Cheney.)

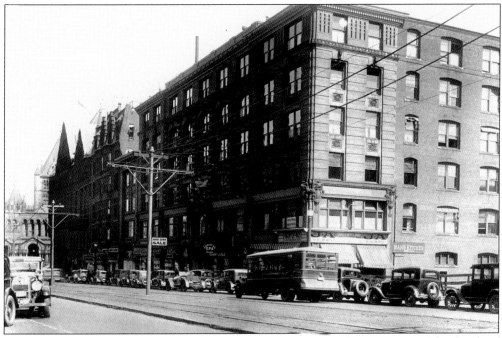

In this view looking down Huntington Avenue toward Copley Square, a part of the facade of Trinity Church can be seen on the far left. In the center is the S.S. Pierce building, designed by Edwin Tobey and built in 1887, which catered to the refined palate of Boston Brahmins. (Courtesy Frank Cheney.)

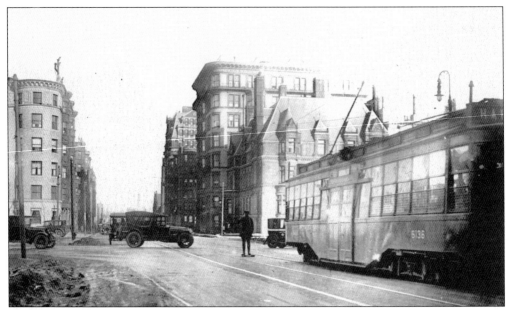

In this view, which looks north on Massachusetts Avenue at Commonwealth Avenue, a policeman directs traffic as streetcar 6136, which ran on the Harvard-to-Dudley line, passes. On the left is an apartment building designed by McKay and Dunham and built in 1892. On the right is the townhouse of Oliver Ames, designed by Carl Fehmer and built in 1882. (Courtesy Frank Cheney.)

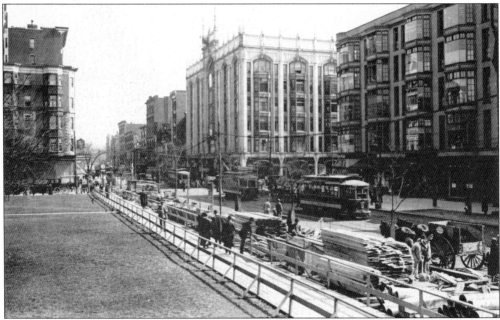

The excavation for the Boylston Street subway can be seen in this view from the lawn of the natural history museum near Berkeley Street. What had once been principally a residential street from 1860 to 1900, with the museum and MIT, had become overwhelmingly commercial thereafter. In the center is the impressive terra-cotta Berkeley building, designed by Codman and Despardelle and built in 1905. (Courtesy Frank Cheney.)

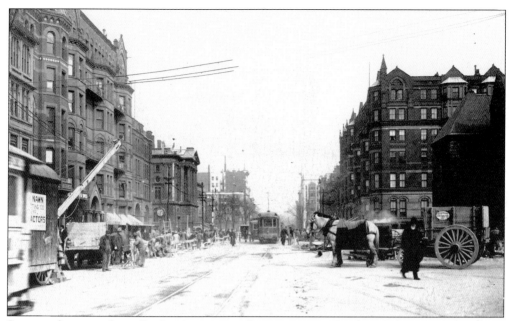

Seen in this view from Copley Square are the excavations for the Boylston Street subway. On the left is the Hotel Cluny, designed by J.P. Putnam. The columned facade of the Rogers Building is just beyond the hotel. On the right is the Brunswick Hotel, designed by Peabody and Stearns and built in 1873. (Courtesy Frank Cheney.)

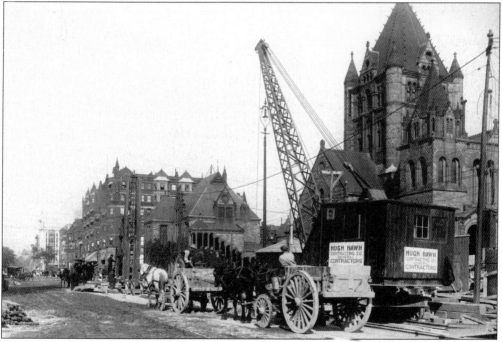

The excavation and pile driving of the Boylston Street subway was undertaken by the Hugh Nawn Contracting Company, a successful Roxbury company. The tower of part of the facade of Trinity Church, designed by H.H. Richardson, can be seen on the right. To its left is a part of the chapel. In the distance is the Brunswick Hotel. (Courtesy Frank Cheney.)

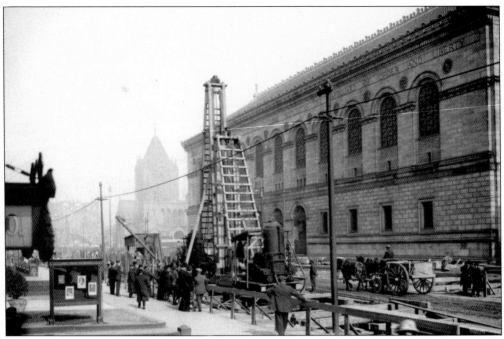

Steel sheet piling is being driven during the construction of the Boylston Street subway. On the right is the Boylston Street facade of the Boston Public Library, designed by McKim, Mead, and White. The signboard of Bachrach Photographers is on the left. (Courtesy Frank Cheney.)

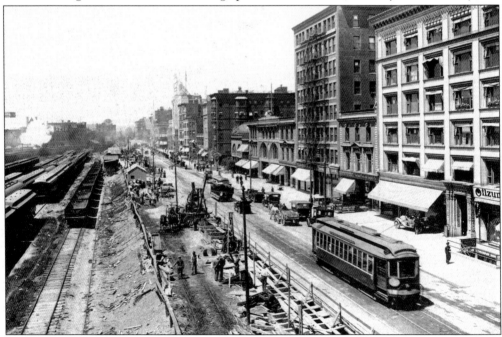

In this view, looking west on Boylston Street from the Hotel Lenox, the excavations for the subway continue toward Massachusetts Avenue. On the right, between Exeter Street and Massachusetts Avenue, are commercial structures. On the left are the railroad yards of the Boston and Albany Railroad, now the site of the Prudential Center. (Courtesy Frank Cheney.)

124

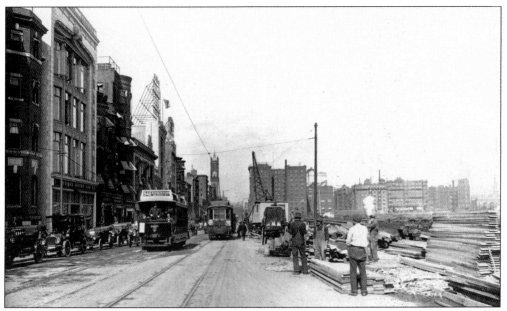

This view, looking east on Boylston Street from Hereford Street, shows streetcar 3227 heading west toward Reservoir via Beacon Street in Brookline. The bell tower of New Old South Church can be seen in the center, with the Hotel Lenox to its right. (Courtesy Frank Cheney.)

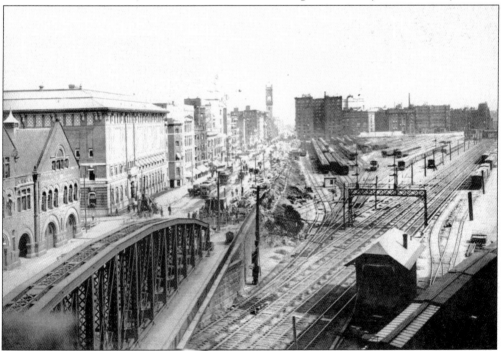

In this view, looking down Boylston Street from Massachusetts Avenue, the Boylston Street firehouse, designed by Arthur Vinal and built in 1887, and the Tennis and Racquet Club can be seen on the left. The railroad yard is on the right on the site of today's Prudential Center. In the center distance is the bell tower, or campanile, of the New Old South Church. (Courtesy Frank Cheney.)

The subway station at Massachusetts Avenue of the Boylston Street subway nears completion in the early 20th century. The Boylston Street firehouse is in the center distance, with the bridge on the right spanning the tracks of the railroad yard. (Courtesy Frank Cheney.)

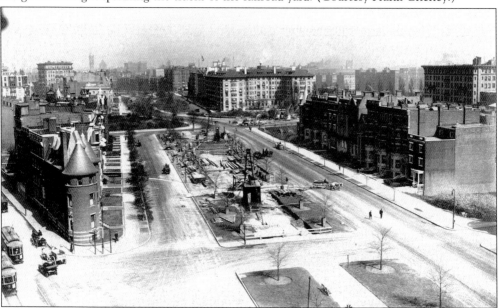

The Back Bay Fens, originally known as Muddy River, was developed at the turn of the century with Beacon Street intersecting Commonwealth Avenue at Governors Square, now known as Kenmore Square. In the center, which had been an extension of the Commonwealth Avenue Mall, the excavations for the subway system for Kenmore Square are being undertaken. In the center is the Hotel Somerset, designed by Arthur Bowditch and built in 1897. The turreted house on the left was designed by Walter and Kimball and built in 1895. Today, it is the Waterman Funeral Home. (Courtesy Frank Cheney.)

J. Murray Forbes gets into his car with license plate 4119 in front of his townhouse at 107 Commonwealth Avenue. His former coachman, now chauffeur, Peter stands on the left. By the early 20th century, most of the Back Bay families had sold their horses and carriages and purchased horseless carriages, which were large cars garaged in special buildings while the former carriage houses were converted to apartments and small homes. (Courtesy the Captain Forbes House Museum.)

The Back Bay, by the early 20th century, had become not just a fashionable residential district, but streets such as Boylston and Newbury had become shopping areas, attracting people who often drove to town. Here, Boylston Street near Arlington Street had two-way traffic that was as dense as that of today. (Courtesy Frank Cheney.)

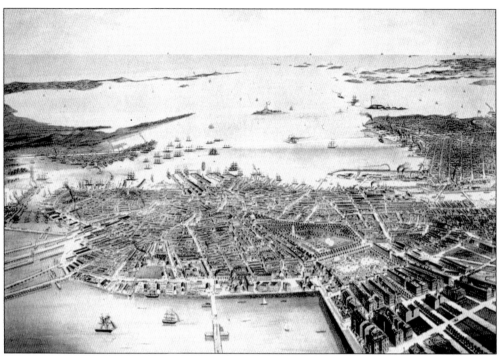

The bird's-eye view above shows Boston as it appeared in 1870. The view below, also from the 1870s, looks from the Massachusetts State House on Beacon Hill toward the Back Bay. The development has extended toward Clarendon Street, past the Public Garden, seen in the foreground. The spires are the Arlington Street Church, on the left, and the Church of the Covenant. On the left is the shedlike roof of the coliseum at Art Square, where the Peace Jubilees were held following the Civil War.

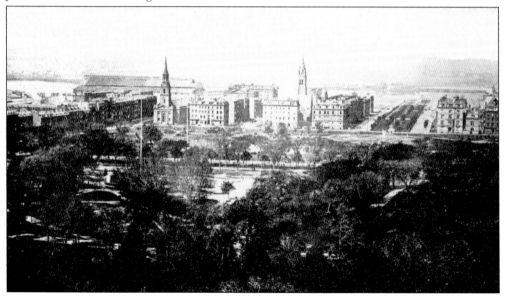